Kai Kappel

DACHAU
CONCENTRATION CAMP
MEMORIAL SITE
Religious Memorials

With a contribution by Björn Mensing
and Ludwig Schmidinger

Translation: Margaret Marks

Deutscher Kunstverlag Berlin München

PREFACE

After the end of the National Socialist dictatorship, the churches hesitantly began to turn their attention to the events of these twelve years, and to recognise the sufferings of the victims. But answers are still being sought as to how it was possible for all this to happen and how such crimes against humanity can be avoided in future.

One of the answers was to erect religious memorials on the grounds of the former Dachau concentration camp. The names given to these memorial buildings show a path with several stations, dedicated to the memory of Christ's Passion and the hope of resurrection. For example, the Mortal Agony of Christ Chapel (1960), open towards the camp road, recalls the suffering of countless people in this place. For many of them, it was comforting to know that their God had experienced fear, hardship and death himself, because they believed and hoped that there might be salvation and release from this – precisely by passing through suffering: they believed that none of those murdered loses his or her own dignity, even if by outward appearance it has been destroyed by scorn and mockery. This is expressed yet more strongly in the dedication of the Carmelite Convent of the Precious Blood (1964): it was not only, it is not only a question of anxiety and affliction, but of life and death. In his son, God himself stands at the side of humiliated and slaughtered humanity: his death is the final renunciation of the rule of violence and counter-violence, the ultimate decision to take the path of surrender out of love. Since that time, the nuns have recalled this dedication in their presence and their prayer, to which all are invited.

With the founding of the Jewish Memorial and the Church of Reconciliation (1967), attention is drawn to two other poles that today remain essential for remembering and commemorating:

The words of the psalm, "Put them in fear, O Lord: That the nations may know themselves to be but men" (Psalm 9:20) stand over the entrance to the Jewish Memorial – an admonition to Christians too not to deny or repress their own unfortunate share in the development of the anti-Judaism that goes back to New Testament

times, but to overcome it with the Biblical and universal promise of redemption.

Concentration camp inmates from abroad, particularly from the Netherlands, made it clear that redemption can be lived and experienced concretely when they expressed a desire for the Church of Reconciliation to be so named and involved their fellow-believers in Germany in this choice through the Conference of European Churches.

It is precisely by taking the injustice suffered seriously, through encounters between human beings, that hope for the future can be made possible, so that finally our vision is enlarged and we have the possibility of realising what is expressed in the Resurrection Chapel (1995): its main icon shows Christ resurrected, leading the inmates of the camp out of their barracks through the gate, which is opened by angels. This is the fundamental promise of faith: that it is not the forces of death that have the last word, but he who is Lord of life.

We thank PD Dr. Kai Kappel for his felicitous presentation of the religious memorials on the Dachau Concentration Camp Memorial Site, which contributes to clarifying and publishing the fundamental concerns of religious commemoration. In this, he assists in a task that is not merely a duty and a challenge for our churches, but also a legacy and an opportunity to further develop our cooperation in ecumenism and in dialogue between Christians and Jews.

Dr. Johannes Friedrich	Dr. Reinhard Marx	Longin von Klin
Regional Bishop of the Evangelical Lutheran Church in Bavaria, Member of the Council of the Protestant Church in Germany	Archbishop of Munich and Freising, Chairman of the Bavarian Conference of Bishops	Archbishop, Permanent Representation of the Russian Orthodox Church in Germany

PREFACE

The publication of Dr. Kai Kappel's "Dachau Concentration Camp Memorial Site. Religious Memorials" is associated with strong emotions for the victims of the Nazi terror, and above all for Jewish people. In this place, the Bavarian Association of Jewish Religious Communities every year commemorates its brothers and sisters who were robbed of their lives, both in this "school" for murder and also in many other places in Europe.

"Yizkor" (literally: may he remember) and "zakhor" (literally: remember, which is the first word of Deuteronomy 25:17, and often, when the word is quoted, the speaker means not the verse itself, but the commandment to remember) have a long tradition in Judaism. Not only prayers during religious services, but also the many locked and abandoned Jewish cemeteries bear witness to this. Graves are laid out for eternity and are to be marked as such. This is done by a tombstone. Here the deceased is remembered.

Those who have been murdered are remembered in a different way from those who died of natural causes. In Deuteronomy 25:17–19, we read: "Remember what Amalek did unto thee by the way, when ye were come forth out of Egypt; how he met thee by the way, and smote the hindmost of thee, even all that were feeble behind thee, when thou wast faint and weary; and he feared not G-d. Therefore it shall be, when the Lord thy G-d hath given thee rest from all thine enemies round about, in the land which the Lord thy G-d giveth thee for an inheritance to possess it, that thou shalt blot out the remembrance of Amalek from under heaven; thou shalt not forget it".

On the dedication of the Jewish Memorial in Dachau, the highly esteemed rabbi David Spiro, may his memory be a blessing, spoke as follows: "We promise you holy souls that we will not forget you; you are part of our fractured being. An eternal light will always burn for you in our hearts."

Although "yizkor" and "zakhor" are forms of the same word, they have different meanings depending on their context: each of them stands for a different text, of which they are each the first word. Just as the Jewish Memorial in the former Dachau concentration camp is

both a place of prayer, of going into oneself, and a place where we can be close to the fates of our loved ones who died in the murderers' gas chambers, and finally also a place of learning.

A place where later generations find enlightenment, can ask questions and can hear the cry of those murdered: "Do not forget us, so that you may not be forgotten".

I recommend this publication by Dr. Kai Kappel, which is a further piece in the puzzle for all those who are of good resolve never again to permit the incomprehensible to happen.

Dr. Josef Schuster
President of the Bavarian Association
of Jewish Religious Communities

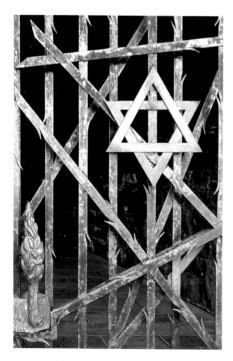

Entrance of the Jewish Memorial in Dachau

INTRODUCTION

On 22 March 1933, one of the first permanent state-run concentration camps was founded in Dachau. What began in Dachau was completed in Auschwitz. Consequently, the name of this town became a synonym far beyond the borders of Germany for the inhuman National Socialist machinery of oppression, "a precinct whose soil burns us through the soles of our shoes, even if we have never set foot on it" (Ulrich Conrads).

Memory attaches to places, "places with the aura of events as nuclei for the crystallisation of understanding" (Wolfgang Benz). Today, if we walk across the vast grey barracks area of the camp, we experience its barrenness and exposure as a physical sensation. Is such a structure really empty of memories? This barren expanse calls up the presence of the 206,000 Dachau camp inmates just as do the International Monument, the museum-like presentation and the testimony in preserved in words, images and text.

Inspired by the animated discourse on remembrance, research since the 1990s has paid far more attention to the postwar use of the former concentration camp and its structuring as a memorial. This book addresses one part of this use, largely relating to the "second history" of the Dachau camp. At the same time, the immeasurable suffering and the death of the camp inmates is constantly present. The central focus is on the religious memorials that were created in connection with the foundation of the Dachau Concentration Camp Memorial Site. In this regard, a central role was played by the clergy who were once confined here, other Dachau prisoners and the families of the victims. These commemorative communities interpreted the history of the concentration camp in their memorial buildings.

The presence of the churches in the Dachau camp has its own history, which dates back to a time before liberation. In all phases of use of the grounds before and after 1945, places for religious worship were created. Some of these church buildings announce a new spiritual and social departure, an earnest intention to engage in commemoration and reconciliation. Many concentration camp prisoners with a religious disposition experienced their suffering as

a martyrdom or a reliving of Christ's Passion. But from today's vantage point, the real difficulties began at the point in the postwar period where the events in the concentration camp were interpreted with reference to *Heilsgeschichte* (an interpretation of history stressing God's saving grace), where a theology of the victim in words and images directed attention away from the dialogue of individuals on responsibility and guilt, which was so urgently needed, and where the National Socialist crimes were robbed of their concrete character and dehistoricised. In addition, the involvement of some protagonists with National Socialism is painful. "In both German states, the way they dealt with the sites of National Socialist crimes was always a yardstick for society's ability to confront history" (Stefanie Endlich).

If one studies the history of the reception Dachau concentration camp, now sixty-five years old, it becomes clear that the works of art and buildings installed here are works linked to their time. Again and again one realises that our present culture of commemoration is not that of the early postwar period, nor even that of the 1960s. But the millions of victims of the National Socialist regime are more than ever deserving of our thoughts, prayers and efforts; and so these Dachau buildings are twofold: they are historical sites and living places of remembrance.

Churches and chapels on concentration camp grounds were and are rarely built. One geographical concentration of such buildings is in Bavaria and Austria, where the old tradition of devotional and wayside chapels still survives. The first building after the end of the war was the Heilig Kreuz (Holy Cross) Church, to be described below, built at the end of 1945 on the camp site: a church by perpetrators for perpetrators. In contrast, the later chapels in the former concentration camps of Flossenbürg (1946–1947), Hinzert (1948) and Mauthausen (1948–1949) were expressly intended as memorials for the victims. The Flossenbürg memorial concept was developed above all by Polish displaced persons – together with the museums founded in Majdanek (1944) and Auschwitz-Birkenau (1947), it was at the forefront of concentration camp memorial sites in Europe.

Chapels and churches beside or on the grounds of concentration camps were built only in the first years after the end of the war,

and then again from 1960/65 (Dachau; Church of Expiation of the Precious Blood in Bergen; St. Theresia in Linz/Austria; convent in Esterwegen). If one considers the West German culture of remembrance, these were the times in which admitting responsibility or critically examining the events of recent history began to take their place alongside the very common response of silence. The system of the German Democratic Republic did not permit any such church buildings.

Those who suffered in a concentration camp comprise Jews, Christians, people of other religious communities, agnostics and atheists, and therefore it was and is somewhat controversial for symbols of the cross and churches to be erected there in a prominent position (one need only think of the events in Auschwitz in the years 1984 to 1993). It is not only now, in our culture of remembrance of the specific victim, that discomfort is felt with regard to such installations. When, in 1948, the laundry barrack of Mauthausen concentration camp was to be converted into a chapel, the Austrian Finance Ministry remarked: "The victims of Mauthausen included members of all faiths, while the chapel would be used only by the Christian denominations alone". In Mauthausen there are now secular and ecclesiastical memorial rooms next to each other.

Since 1967/95, a community of religions and denominations has been created at the north of the Dachau memorial site. The period of time involved meant that there was not one single religious memorial site here. But at all events the communities have close connections with each other, cultivate ecumenism and support each other. May it remain so.

This publication project was made possible by the support and friendly assistance of many. Particular thanks should be given to those on the site in Dachau. The Evangelical Lutheran Church in Bavaria and the Ausstellungshaus für christliche Kunst Association in Munich made it possible for the volume to appear by making substantial subsidies to the printing costs. Our warmest thanks go to all of them.

THE DACHAU CAMP CHAPEL (1941) – THE HOUSE OF GOD IN THE CONCENTRATION CAMP

The history of the chapel

Between 1933 and 1936, the Dachau parish priest and camp chaplain Friedrich Pflanzelt (1881–1958) and Protestant clergy of the Innere Mission in Munich held occasional religious services. From the end of 1940, on the orders of the Reichsführer SS, the priests of all concentration camps were gathered in Dachau. The President of the German Conference of Catholic Bishops, and in particular the Vatican, repeatedly intervened in their support. A total of 2720 mainly Catholic clergy of twenty nations (including 447 Germans and Austrians and 1780 Poles) lived in barracks 26, 28 and 30. A room for worship was created for them in Barrack 26. Seen from the roll-call square, this is the third-from-last block on the left-hand side of the camp.

In August 1940, a site of religious worship for clergy had already been created in Sachsenhausen concentration camp. The first mass was celebrated in the Dachau camp chapel on 22 January 1941. There was a camp chaplain specifically for this purpose, and Protestant clergy too held services in the camp chapel. Soon, the "special prisoners" in what was known as the bunker were also permitted to celebrate the Eucharist. From September 1941 on, the priests confined at Dachau were divided by nationality, and for the time being only Germans and Austrians were permitted to use the chapel. The Poles continued their worship in secret, until the end of 1944.

On official visits to the camp, the camp chapel was used as a showpiece to demonstrate the ostensibly humane treatment of the prisoners by the National Socialist dictatorship. But the reality was different: "There is no [atrocity] that the SS did not commit," wrote the Jesuit Léon De Coninck (1889–1956). Of the 2720 clergy confined in Dachau, 1034 died, including 868 priests from Poland alone.

Despite all the national and denominational divisions, what came into being here was more than merely an "ecumenism for

the sake of sheer survival" (Birgit Weißenbach). Protestant and Catholic clergy met for joint evening services in the Block 26 dormitory. In the middle of the war, on 17 December 1944, the French Bishop Gabriel Piguet (1887–1952) here ordained the seriously ill Karl Leisner (1915–1945) – conspiratively, but with the knowledge of the church governing bodies. From the beginning of 1944, laypersons were also admitted to the chapel, provided this was done discreetly.

After liberation, the camp chapel was used for many years for other purposes. In 1960 it was restored in part, but in 1963 it was demolished.

The building

The camp chapel was created by converting Barrack 26. On the instructions of the camp kapo, workmen removed the partition wall between the sleeping and living areas in Room 1, creating a room 20 m long, 8.75 m wide and only 3 m high. The walls had painted crosses and lilies, and there were wallpaper-like patterns on the altar wall. At first, laypersons were not admitted, and so the building was separated from the inmates' camp by a wire fence. The windows, which at first had painted red crosses, were eventually whitewashed to make it impossible to look in from outside.

The chapel was furnished, paraments and liturgical implements acquired, and there were a large number of embellishments: this was done partly by the clergy themselves and partly with the help of donations from outside churches. A relic of Brother Konrad of Parzham was sent from Altötting. The altar stood against the east wall of the block, which was the wall directly adjoining the camp road. At first the altar consisted of tables covered with white sheets. There was also a lectern.

A second altar stood in front of the north-east corner, for the worship of a 110 cm high carved wooden Madonna and Child. It originally came from Breslau (now Wrocław; the artist was probably E. Hoepker); in spring 1943, it reached the Dachau camp as a

Site of Barrack 26, location of the former camp chapel

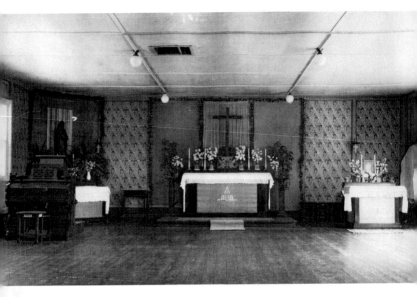

Former Dachau camp chapel (taken on 30.4.1945)

donation by Salvatorians. For the priests confined here, the Madonna became a spiritual point of reference of the utmost importance. Soon it was referred to as Our Lady of Dachau.

Even at that time it was becoming clear that: "The camp in which the SS had gathered Catholic priests was predestined to take on a special role in coming to terms with Germany's National Socialist past" (Detlef Hoffmann). The prisoner priests expected the Madonna later to be part of a much visited place of pilgrimage or prayer ("basilica of atonement"). At the instigation of auxiliary bishop Johannes Neuhäusler (1888–1973) its colouring was removed and it was placed in the church of the Dachau Carmelite Convent. To emphasise the camp's Christian tradition, part of the camp chapel altar was incorporated in the altar of the Carmelite Convent church. In the forecourt of this Convent, paraments and liturgical instruments from the former camp chapel are on display behind glass.

CHRISTIAN MEMORIALS
AND CHURCH PLANS
AFTER LIBERATION

The Dachau concentration camp was liberated by U.S. troops on 29 April 1945. Shortly afterwards, on 3 May, came the Polish national holiday. In the previous night, former Polish prisoners erected a 12 m high cross on the roll-call square. The whole camp, and above all this place, which stood for shared suffering, now bore a Christian symbol visible from far and wide. For the Poles, who were the largest national group in Dachau, the cross on which Christ suffered represented the lack of freedom of their nation (since far earlier, following the political events of 1830/31) and also the suffering and sacrifices of each individual. Shortly after liberation, there was an altar near the camp chapel with the Black Madonna of Częstochowa, and at the end of 1945 a catafalque with a cross outside the crematorium.

German priests interned in Dachau developed the idea of a church of atonement at an early date. They included the former Dachau prisoners Father Otto Pies (1901–1960) and Father Leonhard Roth (1904–1960), and Friedrich Pflanzelt (1881–1958), the parish priest and archiepiscopal delegate for Catholic pastoral care in the camp. At the end of May 1945, Pflanzelt said in a sermon: "A church of atonement is to be built so that the memory [of the crimes in the concentration camp] does not die".

In May or June 1945, the plan arose in these circles to build a Convent of Perpetual Adoration over the Dachau crematorium. This important relic of the most recent past was to be given the function of a legitimising tomb or sanctum, recalling Early Christian and medieval church buildings. Insa Eschebach sees this as "incorporating the site of terror into the Economy of Salvation". From May 1945, Michael Cardinal von Faulhaber (1869–1952) supported the plans for such a memorial of atonement. He had a model prepared for a concentration camp memorial church – a model "in the old style" as Father Roth noted with regret. Fortunately, the project was never carried out. Von Faulhaber did not succeed in persuading

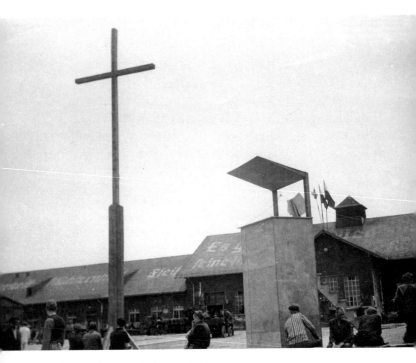

Cross on the camp roll-call square (1945)

the Military Governor, General Dwight D. Eisenhower (1890–1969). In addition, the newspaper *Münchener Zeitung* appeared on 28 July 1945 with the lead story "Dachau as a place of pilgrimage?", which was followed by strong public criticism.

The community of Catholic clergy who had been interned here (in particular Father Leonhard Roth) constantly cherished the idea of building a church or monastery of atonement in the Dachau camp. This idea was revived in 1949, 1955 and 1958, and again from 1959 on, when plans were made to build the Mortal Agony of Christ Chapel and the Carmelite Convent

RE-CHRISTIANISATION OF THE PERPETRATORS – THE CATHOLIC CHURCH HEILIG KREUZ (1945)

In 1945 the American occupying forces created a central internment camp for members of the SS and NSDAP functionaries in the former concentration camp; in addition, there were sections of the camp for imprisoned members of the Wehrmacht and for suspected war criminals.

From August to December 1945, some of the inmates built the Heilig Kreuz Church (Church of the Holy Cross) at the north-west of the former roll-call square: evidently as an act of atonement in connection with the forgiveness of sins and as a publicly visible testimony of re-Christianisation. The instigators were Fathers Anton Nobis (1913–1987) and Leonhard Roth (1904–1960). The latter had been a prisoner in Dachau and from 1945 to 1948 he was responsible for the pastoral care of the perpetrators interned here; later he was the parish curate on the Dachau-Ost housing estate. Both clergymen arranged for the building materials for the church. Roth chose the patron saint; he said that this church had been built "with the help of the Waffen-SS members who had found their way home to the church". On 23 December 1945, Heilig Kreuz was consecrated by Michael Cardinal von Faulhaber in the presence of the American camp commander. Von Faulhaber did not refer to the SS members present, as is often written, as "prisoners of war". But the only mention of the question of guilt before this very unusual circle was a statement that personal guilt was to be examined in future (by the courts).

Heilig Kreuz was a broad, long building (12 m wide, 30 m long and only 7 m high). Its altar was at the west end, and it had a stone entrance from the roll-call square, surmounted by a tower. Evidently, the wooden nave was constructed from parts of a barrack – presumably a reaction to the allocation of materials of the time. The interior had a single aisle; in the altar area there hung large buildings of the Evangelists. Caritas and the office of the archdiocese arranged for the furnishings and the bells; in 1946, Paul

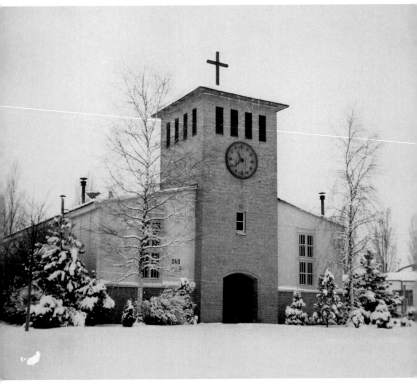

Former Catholic church Heilig Kreuz

Spranger, who was interned at Dachau, built an organ out of tins, petrol cans and zinc plates.

Heilig Kreuz was used from 1945 to 1960; but from 1948 to 1956, the building was seized by the Americans. Since, from 1948/49 on, the Dachau camp was filled with refugees and displaced persons, Father Roth had to find a new church for them. He found it in Block 27/4 (at that time numbered Block 32). During the concentration camp time, this was the location of the punishment battalion; Roth explained this to his parishoners. The Heilig Kreuz church of 1945 was now used for religious services only on important feast days; at the end of 1964 it was demolished.

SYSTEM BUILDING FOR THE REFUGEE SETTLEMENT – THE PROTESTANT GNADENKIRCHE (1952)

From 1948/49 on, large sections of the former prison camp were rebuilt as the Dachau East housing estate for refugees and displaced persons. At first, the Protestants who lived there shared in the use of the room for religious services in Block 27. Then the Gnadenkirche (Church of Mercy) was built at the east of the roll-call square. It was part of an aid programme by the Protestant Church in Germany (Evangelische Kirche in Deutschland, EKD) implemented from 1950–1953 for rural diaspora congregations or for congregations with a high proportion of refugees and displaced persons. It was a prefabricated building of wooden girders. It was largely self-supporting, but its ends rested on stone enclosing walls.

The designer of this specific construction system, known as "diaspora chapel", was Otto Bartning (1883–1959), one of the most influential secular and church architects of the early and mid-20th century. Bartning's concern was to produce affordable and functional churches from standardised, prefabricated construction elements. He had experience in system building, for example from his programme of emergency churches for the whole of Germany (1948–1951). The Dachau Gnadenkirche was donated by the Lutheran World Federation and the Evangelical Lutheran Church of Bavaria. The foundation stone was laid on 24 November 1951; because of its simple structure, the church was completed by 23 March 1952. At the time, priests and high-ranking church representatives said that the name of the church was chosen to indicate to the refugees that there was a permanent place of refuge in the grace of God here; God had now built his church in this place of Satan. The only element that jars is the fact that the first parish priest had formerly been an avowed National Socialist.

The little Gnadenkirche, which measured 11.30 × 14.47 m, had a rectangular hall, well lit from the sides, with a ceiling of horizontal wooden girders, for about sixty worshippers, and also a meeting

Building of former Protestant Gnadenkirche

room, sacristy and small kitchen. On the long saddleback roof was a small support for the bell, which came from Silesia, and the cross.

The last service in the Gnadenkirche was held on 9 November 1963, when the EKD there announced the building of the later Church of Reconciliation. In 1964 the structural elements of the Gnadenkirche were dismantled and eventually transferred to the nearby Ludwigsfeld settlement. There they continued to be used from 1967 to 2005 as the Protestant Church of Golgotha. At present, this room is used by Munich's Georgian Orthodox congregation. To date, it has not been recognised as a listed building.

UNITED IN THE MEDITATION AREA: THE RELIGIOUS MEMORIALS AT THE NORTH OF THE SITE

Above all in the first half of the Adenauer era, there was a "negative history of repression, playing down or denial of the [National Socialist] crimes" (Barbara Distel). Such attitudes were particularly evident at Dachau. Former concentration camp prisoners found a housing estate on the site of their ordeals; only in the area of the crematoria was there a small commemorative site. It was only in 1955 that the attitude changed: the Federal Republic of Germany committed itself to preserve memorials, and the Comité International de Dachau (CID) was re-established. The former concentration camp inmates in this organisation were very active, in cooperation with a Bavarian board of trustees. Gradually, political and public opinion changed in favour of a memorial site.

One of the main actors in this project was Leonhard Roth (1904–1960), a former prisoner at Dachau and at this time parish curate in the Dachau-Ost housing estate. He was of the opinion that the Dachau concentration camp site was a "world sanctuary"; he said that the middle classes were not interested in a memorial, and in order that it did not have a Communist character, it was necessary for it to be supported by the church. As the CID delegate of the concentration camp priests, Roth crusaded from 1956 on for the churches on the former roll-call square to be preserved. When, in January 1959, the CID held a competition for a memorial, Heilig Kreuz (1945) was to be supplemented on the east side of the roll-call square by a Protestant church (probably the Gnadenkirche) and a Jewish memorial room.

Roth's powerful adversary was the auxiliary bishop Johannes Neuhäusler (1888–1973). He was a close colleague of Cardinal von Faulhaber and an expert on church policy, and had been a "special prisoner" in Dachau from 1941 to 1945. From autumn 1959 on, Neuhäusler developed the concept of a religious memorial site at the north of the former prison camp. In its centre there was to be a chapel, for which Neuhäusler began collecting donations in

1958/59. The road axes of the concentration camp remained. Neu-häusler voted for planting vegetation on the site; the present oak trees surrounding the Mortal Agony of Christ Chapel give a rudi-mentary impression of this plan, but recall the groves of honour of German war memorials.

At the end of October 1959, the Dachau priests informed the CID that they were in favour of removing the camp churches of the early postwar period from the roll-call square. Roth told Neuhäusler on 11 November 1959 that the CID had approved the priests' sug-gestion of now erecting a concentration camp memorial church (as a "counter-monument" to the planned International Monument), a Protestant church and a synagogue at the north end of the camp.

However, the only building plan pursued by Neuhäusler was that of the Mortal Agony of Christ Chapel (1960) as a "Eucharistic place of sacrifice". He offered this project to both the Protestants and the Jews to share with him, but both turned it down. At that time the Catholic theological understanding was that the suffering and death of *all* victims and the Passion of Christ were inseparably linked, and Neuhäusler's concentration on one single Christian place of worship in the camp was influenced by this. From this per-spective, the suffering and death of humans was regarded as an act in the imitation of Christ.

In the following period, under the responsibility of the CID's preferred architect, René van der Auwera (Brussels), the present as-sembly of three sites, the Mortal Agony of Christ Chapel in the cen-tre, the Protestant Church of Reconciliation and the Jewish memo-rial was created. At the time of the concentration camp, this "place de méditation" was occupied by the camp market garden, rabbit hutches and the clothes disinfection building. On the initiative of Helmut Striffler (born in 1927), the spatial relationship of the three religious memorials was narrowed. The Carmelite convent was also added.

Kathrin Hoffmann-Curtius has a thesis that the arrangement of the religious memorials on the Dachau camp area was intended to symbolise Golgotha, but no documentary evidence can be found for this. Heinz Meier (1912–1993), the then President of the Bav-arian Association of Jewish Religious Communities, presented a completely different interpretation in 1967. He said that the three

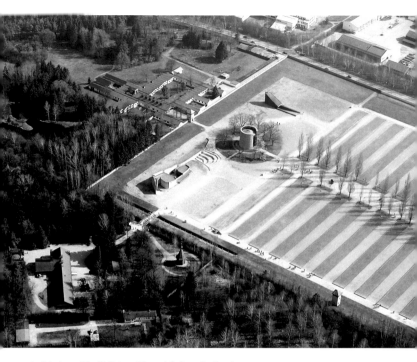

Aerial view of the Religious Memorials from the Southwest

religious memorials represented the inmates' shared journey of suffering and death; they were intended to stand for the ideals of humanity and peace on God's earth. The Carmelite nuns were only concerned that their cruciform convent should adjoin the former camp at its "foot".

When, in 1962 to 1965, the former prisoners' barracks were demolished, the 1941 camp chapel, the Heiligkreuzkirche and the "barrack church" Heilig Kreuz in Block 27 disappeared; the Protestant Gnadenkirche was moved. It was a great achievement, above all on the part of the CID, that the Dachau Concentration Camp Memorial Site was opened on 9 May 1965. The CID's planning of the site was completed in 1968 with the International Monument on the roll-call square.

THE CATHOLIC MORTAL AGONY
OF CHRIST CHAPEL (1960)

The architectural history of the chapel

The community of the former Dachau concentration camp priests had long wished for a church of atonement. Father Leonhard Roth (1904–1960) noted that since mid-1958 auxiliary bishop Johannes Neuhäusler (1888–1973) had included a chapel project of this nature in the programme of the Thirty-Seventh International Eucharistic Congress in Munich (but it is not clear whether this was the case). At all events, as early as 1959 Neuhäusler had collected money for a chapel building at the end of the camp road. When, on 1 September 1959, the highly decorated bomber pilot Leonard Cheshire (1917–1992) and his wife criticised the lack of a religious monument at the Dachau camp, Neuhäusler once more realised that this would not make a good impression on the Dachau visitors from the forthcoming 1960 International Congress. In addition, it may have been important to Neuhäusler, who was well-read and extremely well-informed, to confront the developing criticism of the role of the Catholic church in the »Third Reich« (writings by Böckenförde and Weinberger) with a place in which the National Socialist victims from the church were to be commemorated.

At the end of 1959, a frenzied wave of planning began. The chapel was commissioned in Spring 1960 by the office of the archdiocese; building commenced at the end of April. With the assistance of the Munich architect Josef Wiedemann (1910–2001), supported by a large number of donations from all over the country, and not least as a result of the energetic involvement of the Federal German armed forces, Neuhäusler succeeded in having the chapel built in only four months, in time for the International Eucharistic Congress. At first, a dressed-stone building of basalt or nagelfluh was planned, but on account of cost and aesthetic considerations, this was dropped. The patron saint of the chapel was chosen by Joseph Cardinal Wendel (1901–1960), who wanted to establish an

Dedication of the Catholic Mortal Agony of Christ Chapel (1960)

association between the mortal agony of Christ and the mortal agony of the inmates.

The chapel was consecrated by Neuhäusler on 5 August 1960, during the International Eucharistic Congress. Approximately

25

40–50,000 people crowded between the barrack buildings of the Dachau camp, which at that time were still standing.

Like Peter Blundell Jones and others, one may see this chapel building as a Christian monopolisation of the camp, as a marked change of emphasis away from the roll-call square which is so important to the inmates' memories. In the context of commemoration projects, the chapel and the dedication ceremony were far more than this: a visible sign that in the Federal Republic of Germany in the years between 1958 and 1962 – that is, still in the Adenauer era – there had been a change from the culture of shame of the "quiet" early and mid-1950s to the much-quoted "phase of coming to terms with the past". Events such as the dedication of the chapel played their part in making this process irreversible.

A Friday had been chosen for the dedication. Thus auxiliary bishop Neuhäusler was able to take the imitation of Christ as his subject; on this, he wrote: "At the very hour when our Lord suffered his mortal agony and overcame our death through his death, the memory of the suffering and death of so many people was called to mind in face of the Mortal Agony of Christ Chapel". A "pilgrimage of atonement" of young Catholics that led from Munich into the Dachau camp also referred to the experience of Golgotha. During this pilgrimage Christ was also besought to atone for "all the evil deeds of Hitler's Third Reich", the murder of many millions of Jews and the destruction of so many synagogues. In his speech at the dedication ceremony, the Bishop of Essen, Franz Hengsbach (1910–1991), emphasised "the particularly serious guilt of Germans"; following an interpretive model that had been customary in the church for some time, he saw the horror of Dachau as a result of humans turning their backs on God.

An integral part of the festivities on this 5 August was the reopening of a large part of the former camp chapel in Block 26. The former altar, the Madonna and the monstrance were reinstalled there. In this way, Neuhäusler linked the building of the Mortal Agony of Christ Chapel with the Dachau's church tradition.

The former President of the National Socialist Reichsbank, Hjalmar Schacht (1877–1970) was invited to the dedication of the chapel; he too had been interned in a concentration camp in

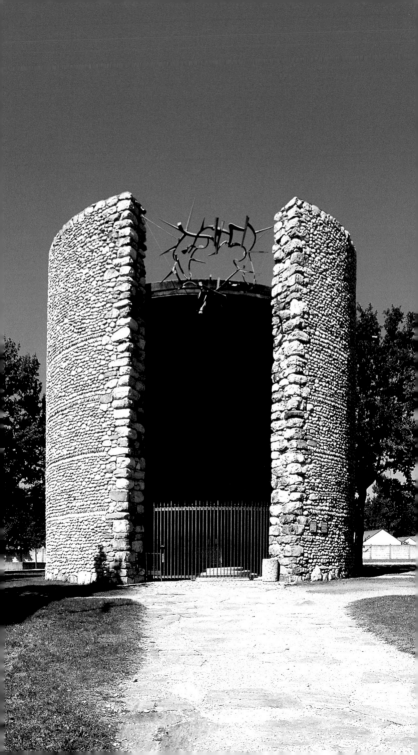

1944/45. However, few people knew of the chapel architect's National Socialist past: Josef Wiedemann – a highly respected professor of design, preservation of monuments and ecclesiastical building at Munich Technical University, greatly esteemed for his sensitive, creative rebuilding of the Odeon and the Siegestor triumphal arch in Munich, positioned between the South German architectural tradition and a moderate modernism, a member of the Bavarian Academy of the Fine Arts – joined the SS in 1933 and was involved in architecture in the »Third Reich« on the Obersalzberg and in Linz. The author finds it distressing that a member of the organisation that was responsible for the immeasurable suffering in the concentration camps should have built commemorative buildings such as the Mortal Agony of Christ Chapel and the Carmelite Convent and in addition was able to plan the future memorial site. It is possible, however, that Wiedemann accepted these commissions precisely in order to do personal atonement.

The building

The circular, emblematic Mortal Agony of Christ Chapel, visible from a distance, forms the end point of the Dachau camp road. Its architects saw it as a religious counterpoint to the planned International Monument on the roll-call square. It is a large cylindrical structure (13.60 m high, diameter 14.20 m) with an inset wooden conical roof conveying an impression of lightness, with wooden ribs beneath. A wrought copper crown of thorns appears to hover over the entrance area. The building is a concrete skeleton construction, cladded on both sides with 15–20 cm pebbles from the River Isar; an old method used in house-building was adapted for this purpose. The horizontal bands of smaller pebbles arranged in a herringbone pattern serve as equalising courses and ornamentally structure the shell. The diameter of the building narrows, scarcely perceptibly, by 14 cm from the lowest third upwards, giving dynamism and plasticity (similar to the effect of entasis in classical columns). The opening, facing the camp road, is approximately 4.5 m wide and gives the impression of having been cut out

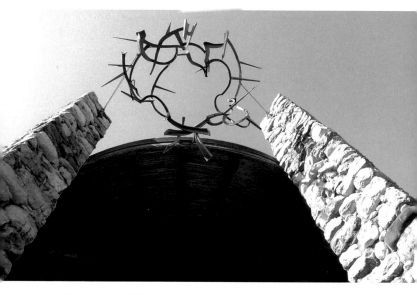

Catholic Mortal Agony of Christ Chapel, crown of thorns

of the wall; on closer inspection it can be seen that it is bordered by hammer-dressed masonry.

The Mortal Agony of Christ Chapel is strongly related to the lay-out of the former concentration camp; this may have resulted from Neuhäusler's reflections on life in the camp. Wiedemann said that in this building he wanted to unite all the people who had walked along the camp road.

The interior of the chapel has remained largely unchanged. In the centre of the surprisingly large space, whose only design elements are the pebble floor, the structure of the masonry and the slender, apparently floating roof, rises a circular altar island, raised by three steps. Small and medium-sized groups gather here, forming an open or closed ring, around the altar with the celebrant. The large-scale altar, rectangular and block-like, is of Brannenburg nagelfluh stone. It bears four candlesticks, and between them a plain, strongly stylised metal crucifix. As at the time when the chapel was dedicated, a simple, freely suspended wooden cross

(a Greek cross) hangs above the altar. Wiedemann had originally planned a more powerfully designed cross with a small crucifix; provisionally, a corpus had been attached to the cross. On the walls there are fittings to hold wreaths.

According to Wiedemann, the Mortal Agony of Christ Chapel is also to be a place of commemoration for individuals and small groups. Unfortunately, it is usually closed by a roller grille (from the time when it was built).

Encompassing figure, symbolic architecture

The Mortal Agony of Christ Chapel processes impulses from architectural history (Early Christian mausoleums in Rome, baroque chapel rotundas, Totenburgen ("castles of the dead", a form of German war memorial) of the German War Graves Commission). But the most important stimulus came from the interface between architecture and theology/liturgiology: after all, the chapel was built shortly before the Second Vatican Council, which sanctioned many requests of the Liturgical Movement.

In his book "Vom Bau der Kirche" (On Church Architecture), which appeared in 1938 and again in 1947, the well-known Catholic church architect Rudolf Schwarz (1897–1961), one of the main participants in the Liturgical Movement, published draft plans of the spatial relationship between congregation, celebrant and altar. Schwarz's ideas concerned the enclosing architectural form. In the postwar period, these sketches and descriptions were widely distributed; Neuhäusler and Wiedemann will have discussed them.

Schwarz's second plan was entitled: "Sacred departure (The open ring)". Here, the celebrating congregation are gathered around the altar, and one-quarter of the circumference of the circular space is opened up beyond the altar. Schwarz said: "[The plan] is to weave intimacy and distance, enclosure and opening, existence and path into a unity and to open a space into the infinite. […] Light-filled emptiness penetrates as far as the altar." Schwarz's fifth plan, "Sacred trajectory (The dark chalice)" confronts God's chosen

Catholic Mortal Agony of Christ Chapel, interior

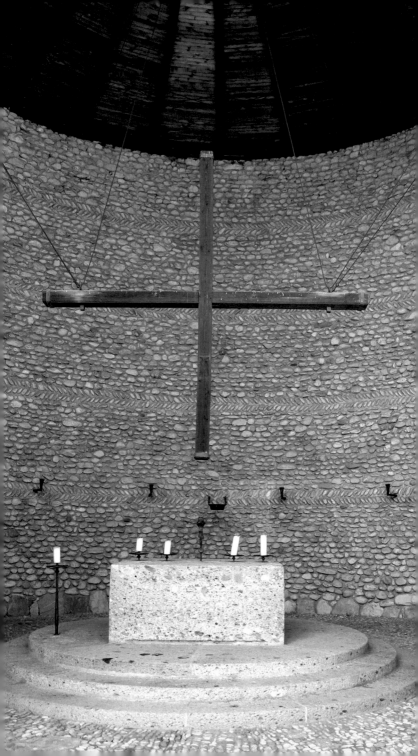

Catholic Mortal Agony of Christ Chapel, view of the camp road over the altar

people, moving towards it, tired from the long road through history, with a large, accommodating architectural form, a windowless, rounded hollow form: "They come in a long train from afar, they have almost completed their journey and now reach their goal. Wide open, the heavens wait. There in front sits the Lord, he opens his arms towards the approaching procession […]; the altar is the place where he waits for his people". Such a building should be closed off from the surroundings at least by a gate. In Schwarz's seventh plan, the "cathedral of all ages", a rotunda with a segmental opening is named as one of the two liturgical destinations.

In this context it is important to note that Josef Wiedemann was part of the planning team that in 1959–60, for the Munich and Freising archdiocese, supplied the design for the altar complex for the large church services at the International Eucharistic Congress; the altar island stood here in the centre of the assembled faithful, which was intended to encourage the worshippers to take an

MORTAL AGONY OF CHRIST CHAPEL

active part in the liturgical events and which had far-reaching effects, not only for the design of the Dachau chapel.

Wiedemann's Mortal Agony of Christ Chapel has an enclosing form which recalls the full garments of the Madonna of the Protecting Cloak. The crown of thorns, facing the camp, is intended to symbolise that Christ suffered and died for all of us, above all the camp inmates. Again and again, Neuhäusler spoke of a chapel of atonement or a cenotaph or atoning memorial. He compared the architectural form, referring to Isaiah 63:3, with a gigantic wine press, although this particular text is problematical with regard to the relationship between victims and perpetrators in Dachau. The architect Wiedemann was guided by the "idea of a tower as the symbol of captivity, a tower that takes in the camp road and is opened towards it, liberation."

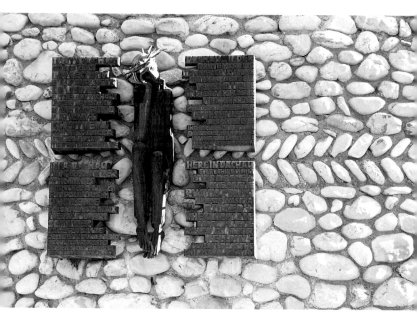

Catholic Mortal Agony of Christ Chapel, commemorative plaque for the Polish prisoners

An international memorial site

The bell weighs 3000 kg and hangs in a freestanding frame beside the chapel; it was dedicated only on 22 July 1961. It was donated by the Austrian prisoners' association and the Austrian federal government. The bell bears the following inscription: "Dedicated by Dachau priests and laypersons from Austria in faithful memory to the deceased comrades of all nations". Every afternoon at the hour of Jesus' death, it rings to prayer for the victims of the concentration camp.

On 19 August 1972, Cardinal Döpfner (1913–1976) unveiled a bronze commemorative plaque on the north side of the Mortal Agony of Christ Chapel. This was donated by the Polish priests interned in the Dachau concentration camp. It tells in four languages of the suffering and death of Polish prisoners in Dachau. The individual sections of this plaque seem to float freely in front of the chapel wall; in the centre there crouches a grossly elongated emaciated Christ, marked by the Passion, in prison garb.

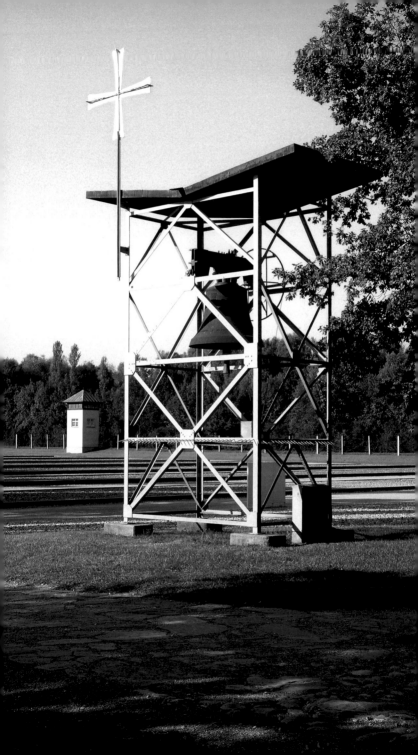

THE CARMELITE CONVENT OF
THE PRECIOUS BLOOD (1964)

The architectural history of the convent

D The building of a Carmelite convent on the site of the former Dachau concentration camp is part of endeavours over many years to establish a church or convent of atonement. In addition, the planned Concentration Camp Memorial Site was to be given as Christian a character as possible.

On 4 November 1959, Father Leonhard Roth (1904–1960) suggested to auxiliary bishop Johannes Neuhäusler (1888–1973) that a convent of atonement should be built beside the planned memorial church. Neuhäusler thought it essential that a large room for Catholic worship should be attached to the Mortal Agony of Christ Chapel. The building of the convent was particularly encouraged by the prioress of the Carmelite convent in Bonn-Pützchen. Maria Theresia von der gekreuzigten Liebe (1911–1970) was born in Munich and closely connected with the youth work of Father Alfred Delp (1907–1945). On 22 January 1962, the prioress explained her convent project to Julius Cardinal Döpfner (1913–1976) as follows: "A place where such crimes were committed, where so many people suffered the unspeakable, may not be reduced to a neutral place of commemoration, and less still to a tourist site. Vicarious atonement was to be made there through the sacrifice of our Lord Jesus Christ and, connected with this, through the sacrifice and atonement of people who follow this suffering and atoning Lord in love and obedience. – The Carmelite Order has a special vocation of sacrificial and atoning prayer".

On 1 August 1962, Cardinal Döpfner gave his consent to the foundation of a convent. Neuhäusler organised donations for what he referred to as the convent of the atonement, and he pushed the building project forward. In letters of petition, he called for atonement to be made in this way for the sins committed by Germans in Dachau and elsewhere. In 1962, the commission was given to the architect Josef Wiedemann (1910–2001); he carried out this project

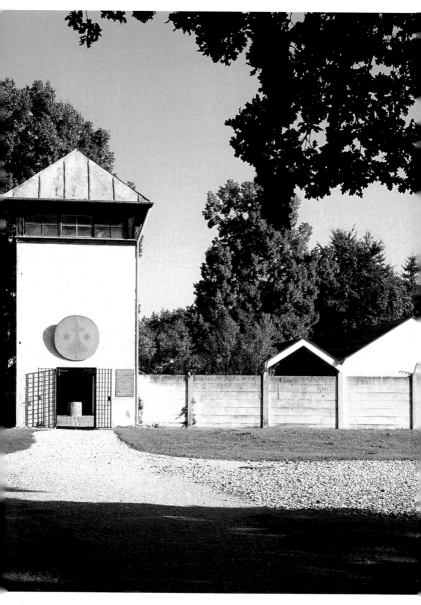

Former watch tower as an entrance to Carmelite Convent of the Precious Blood

together with Rudolf Ehrmann, and Oswald Peithner as building supervisor.

The first plan considered was a convent building in the area of the camp barracks. But soon Neuhäusler suggested an area to the north of the former prisoners' camp. Admittedly, the nature of the soil there created problems for building; for this reason and on account of the overall proportions of the memorial site, the convent was built with only one storey. The foundation stone of the Carmelite convent was laid on 28 April 1963, the day before Liberation Day. Here, Neuhäusler was reacting to Rolf Hochhuth's play "The Representative" ("Der Stellvertreter") which criticised the church. Neuhäusler said that only self-knowledge, an honest acknowledgement of one's own guilt and atonement would help to demolish "the gigantic mountain of guilt piled up by the German people".

The architect Wiedemann studied the rules of the Order, visited Carmelite convents, and informed himself about the community committed to prayer and silence. At the same time, there was a desire that the genius loci and the needs of modern life be taken into account. According to a contemporary newspaper article, an "open and a cloistered world under a common roof" were planned. Originally, the strictly cloistered Carmelite convent was to have a pilgrimage (presumably to the Madonna from the former camp chapel) and a parish.

Mother Maria Theresia moved to Dachau with a few nuns in September 1964; they helped with the building. Their community was characterised by the concept of atonement. The presence and prayers of the Carmelite sisters were intended to constantly commemorate the victims, and to make atonement on our behalf. Atonement was to be understood as reconciliation.

On the dedication of the convent on 22 November 1964, in the presence of many former prisoners and high-ranking politicians, Cardinal Döpfner remarked that the silent prayer of the sisters was not enough, since even in a democracy events happened that were not unlike the spirit of Dachau. He said that the sisters should not only make atonement, but also send their prayer out into the world.

The buildings

The spiritual connection to the suffering of the concentration camp inmates was also expressed topographically: The Carmelite convent is in the form of a cross; its forecourt immediately adjoins the former protective custody camp. Referring to the main form of the complex, which embodies Christ's death on the cross, its architect Josef Wiedemann said as follows: "The cells surround the altar like a herd its shepherd. The whole grows together to a single form: the cells are the arms; the cloister [adjoining at the north] the head, the chapel with the choir the body; the sacrificial altar with the tabernacle the heart; the gate and presbytery the feet, which touch the camp wall. The form is the cross."

The convent takes up the direction of the camp road as its central axis. To emphasise this, the originally planned side entrances were replaced by an entrance through the north watch tower of the camp. This is an eloquent design, but not without problems

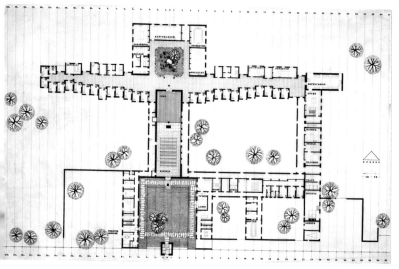

Carmelite Convent of the Precious Blood, ground plan (Büro Josef Wiedemann)

from the point of view of the preservation of monuments. (In 1947, a camp watch tower had already been sacralised by being integrated into a chapel at Flossenbürg.) In the meantime, the altar and liturgical implements had been brought from the 1941 camp chapel to the northern watch tower.

Influenced by modular planning and the use of the grid in contemporary architecture (Mies van der Rohe's IIT campus in Chicago, Le Corbusier's La Tourette Dominican monastery), Wiedemann selected a standard module dimension of 3.00 m axis width for each of the twenty-one sisters' cells. This determined the proportions of the entire Dachau Carmelite convent; for example, the common rooms are twice this width and the choir of the church three times. However, the architect departed from this grid measurement in details.

For Wiedemann, church architecture was not a compulsive manifestation of a future situation, but a dialogue of the present with tradition, with history. The existence of several courtyards and garden areas planted with trees in the Dachau convent shows how involved Wiedemann was in a creative dialogue with the atriums and cloisters of Early Christian and medieval churches. Wiedemann worked in the South German architectural tradition and was an enthusiast for exposed materials ("authentic materials", "truth to materials"). He said that exposed concrete was acceptable in ecclesiastical building, but he particularly appreciated the filigree tectonics of brick walls: for him, they gave the building proportion and order.

Throughout the convent one encounters an elementary, reductive formal syntax, showing truth to materials: floors of brick and boards, simple wooden doors, spare geometrical furniture, emphatically slender supports, unstructured brick walls lacking bases and cornices, either exposed or whitewashed, and shallow concrete folded-plate roofs, which evoke both the camp barracks and the prototype of a house. Like other architects of the time, in the later 1950s and in the 1960s Wiedemann was fond of tent-like terminations in ecclesiastical buildings. In the church and in the residential parts of the convent, the concrete ceilings are faced with spruce boards. On the exterior, the folded plates were simply surfaced with copper. These are all demonstrations of simplicity; it is the simple

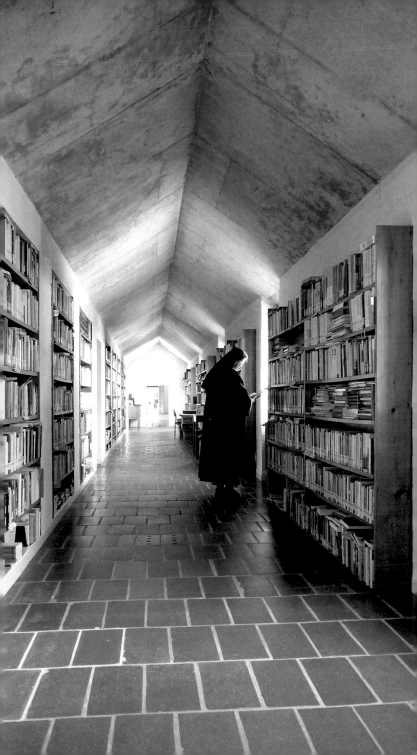

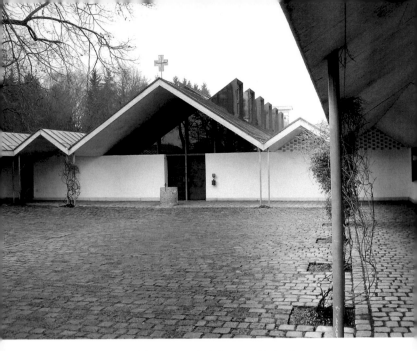

Carmelite Convent of the Precious Blood, forecourt with church

and unpretentious that conveys something of the busyness of emptiness.

At the same time, Wiedemann's architecture was directed to the specific requirements of the Order: he said that the room "should resemble a simple habit just like a second garment. [...] This building is a garment for hermits who have built their huts". Critics of architecture saw it in the same way: it was claimed that the convent took up the outlines of the camp barracks, but transformed them into a humane order of dynamic simplicity and atmospheric density; "... in this modern convent building, one may experience directly, almost corporeally, that architecture can have a purifying effect" (Gottfried Knapp).

Let us take a tour of the convent. Leaving the broad space of the memorial site and passing the northern camp watch tower, we reach the quiet convent forecourt, which is almost square and neatly paved. Thin steel supports carry the two-dimensional concrete folding-plate roofs of the ambulatory, which lie in a north-

south direction. At the left is the priest's wing, at the right the gate-house with the convent shop (from here, the guestrooms and con-ference rooms, surrounding their own entrance courtyard, can be reached). In a glass case, selected memorial items and liturgical im-plements from the camp chapel are presented. Near the north-west corner of the courtyard stands the abstract figurative commemora-tive plaque for Blessed Titus Brandsma (1881–1942) and the Dutch victims of Dachau concentration camp, donated by Dutch citizens. It shows St. Joseph, patron saint of the dying.

The first thing visitors usually see is the glass gable of the church. This spare, elongated church interior has glazed gables at both ends; for Wiedemann, this was a motif that was transitory in the literal meaning of the word: In this way, he said, it was made apparent that the axis of the prison camp "leads through the full depth of the Carmelite convent into another dimension". In a

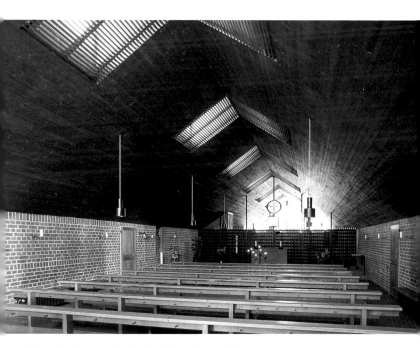

Carmelite Convent of the Precious Blood, church interior

dialogue with the "light cannons" of Le Corbusier (1887–1965), the church ceiling was also given light openings, set into the roof like dormer windows. The integration of the distribution of light and the roof structure emphasises the single-space principle followed here: despite a 12 m wide, elaborately wrought dividing grating (by Manfred Bergmeister after designs by Blasius Gerg), all the congregation, both nuns and laity, are assembled together. It is fitting that the tabernacle (Blasius Gerg) set in the centre of the grating can be seen both by the nuns and by the visitors to services.

Since 1970, the nagelfluh block altar at the end of the area for the laity has contained part of the altar of the former camp chapel in Barrack 26. These "relics" and the Madonna from the same camp chapel installed in a niche in the west wall testify to the Christian presence on the site of the Dachau concentration camp. The carved Madonna and child reached the camp in spring 1943 as a donation from Salvatorians. For the priests imprisoned here, Our Lady of Dachau became a beloved, consoling figure. This attachment continued after liberation. Auxiliary bishop Neuhäusler, once a "special prisoner" in Dachau, was buried in the church of the Carmelite convent as he wished, facing the revered camp Madonna. Wiedemann, as architect, long opposed bringing the Madonna to the church, for stylistic reasons. It was probably his decision that when the sculpture was installed in the Carmelite church, its colouring was removed.

The rectangular nuns' choir and the other parts of the convent are a cloistered area, not accessible to visitors. After leaving the nuns' choir at the north, visitors are standing under a simple bell tower; in accordance with the purpose of this convent, the bell in the tower is the same bell that was used for the death knell in Munich-Stadelheim prison and execution site in the National Socialist time. At this point, a long covered corridor leads away, broadening out on an east-west axis (the "Anger", named after the broad central square or common in some German linear villages). To the south (facing the sunlight, facing the camp), the nuns' cells adjoin. On the ground plan, their rectangles are slightly displaced from each other, which gives a certain dynamism to the structure. The "Anger" corridor is covered by folding-plate roofs of exposed concrete set

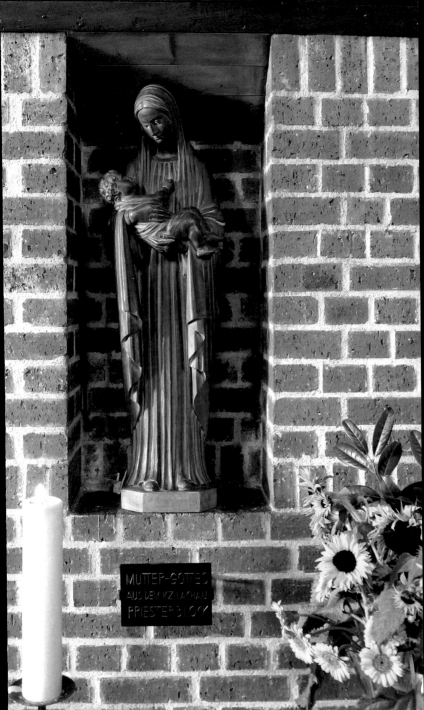

MUTTER-GOTTES
AUS DEM KZ DACHAU
PRIESTERBLOCK

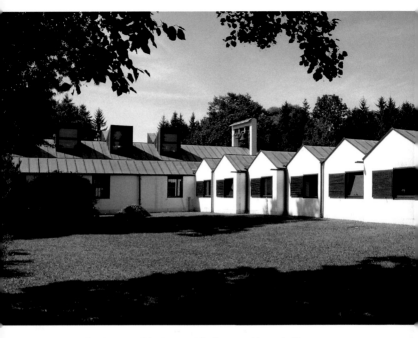

Carmelite Convent of the Precious Blood, wing with nuns' cells

at short intervals in a north-south direction; in the plain nuns' cells there are similar timber-lined ceilings. At the west end of this corridor lies the novitiate, and at the east end the refectory. Opposite the nuns' choir, a rectangular cloister ("quadrum") adjoins the "Anger". In its centre there is a small garden. Around this cloister are central functional rooms of the convent: the chapter house, the recreation area and the sick room. In the later 1970s, the Wiedemann office added a meditation room. To the north of the convent lies the nuns' cemetery hill, surmounted by a cross.

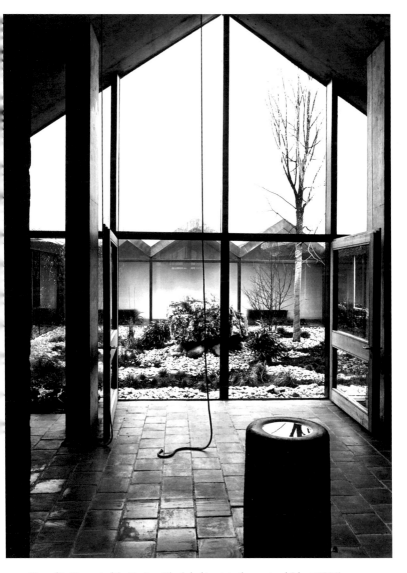

Carmelite Convent of the Precious Blood: looking into the courtyard (about 1964)

THE PROTESTANT CHURCH
OF RECONCILIATION (1967)

The planning and architectural history

W hen, at the beginning of November 1959, the International Dachau Committee approved auxiliary bishop Neuhäusler's (1888–1973) proposal that the planned Mortal Agony of Christ Chapel at the north end of the former prison camp should be flanked by Protestant Christian and Jewish buildings, a discussion became necessary. In 1961, the EKD had been entrusted with this; it now hesitated. Many Protestants had welcomed the 1933 seizure of power and accepted the National Socialist crimes without opposition; nor, to date, had any specifically Protestant memorial area in been founded in a former concentration camp – and was such a site now to be created, in Catholic Bavaria of all places? At most, a simple fenced-in atonement cross seemed appropriate.

The eventual impulse to build a Protestant church came from Dutch Protestants. In summer 1961, a Dutch priest regretted that there was nowhere for him to commemorate his brother, who had suffered and died in the priests' block. From this time on, the "Nederlands Dachau Comité" led by Dirk de Loos (1917–1990) vigorously lobbied for the building project. High-ranking representatives of the EKD such as Kurt Scharf, the Chairman of the Council (1902–1990) and Ernst Wilm (1901–1989), himself pursued by the National Socialist regime, were soon convinced of the necessity of a Protestant commemorative church. But in 1962, first of all alternative sites for such a "church of atonement" were investigated, above all in Protestant Bergen-Belsen. But there, Jewish associations requested that the peace of the dead should not be disturbed by building works. In January 1963, the Dutch Protestants decided in favour of a church in Dachau. They had first proposed a chapel beside the former priests' Barrack 26, but from the end of 1962 they wanted the Dachau church to be planned and built by the Dutch architect Piet Zanstra (1905–2003). On the other hand, in 1962–63

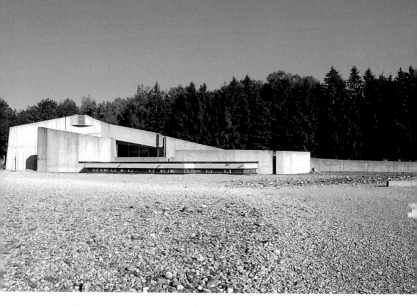

Protestant Church of Reconciliation, general view from the south-west

the Bavarian Church Council in Munich still favoured a place with a cross. But not only the activities of the Dutch, but also the consecration of two Catholic commemorative churches (Maria Regina Martyrum in Berlin and Maria Regina Pacis on the Leitenberg near Dachau, on 5 May and 31 July 1963 respectively) forced the EKD and the Bavarian Protestant Church to act.

On 9 November 1963, the twenty-fifth anniversary of the Night of Broken Glass, in the little Gnadenkirche on the Dachau roll-call square, the Council of the EKD announced its intention to build a new church at Dachau. This was to commemorate all victims of the National Socialist rule. In view of the guilt, the Council stated, it was intended to be a place where worshippers were called on to do penance and to change their ways, to seek God's forgiveness and to be called to make expiation. In this connection, the concept of a Church of the Atonement of Christ was developed, but it was soon dropped because it was too imprecise. The foreign Protestants and former concentration camp inmates involved stated plainly that there was certainly nothing for them to atone here; they wanted a place to commemorate their dead. There followed a complex

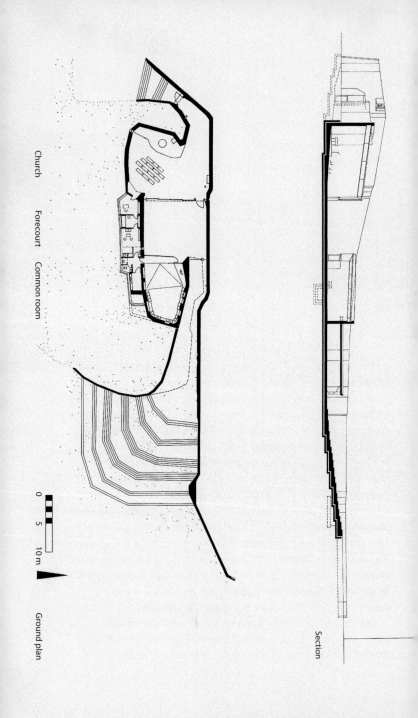

Church Forecourt Common room

0 5 10 m

Ground plan

Section

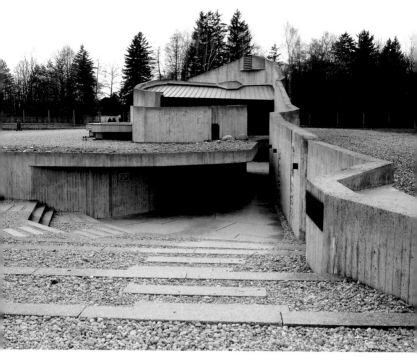

Protestant Church of Reconciliation, general view and entrance area, from the east

process to find a name: Church of Expiation and Supplication, Church of Judgement and Grace, Jesus Christ Church were rejected, finally, the programmatic name Church of Reconciliation was found.

Following the preparation by the working party of the Protestant Church Construction Conference, in 1964 there was a restricted competition between seven architects. Plans were invited for a solution for silent prayer and worship: a room for worship with a variable amount of seating, with a sacristy, an assembly room for talks and discussion holding seventy-five people and an office and further annexe rooms. It was the desire of the founders that a church congregation would develop here, but details were left open. As a mark of respect towards the Dutch initiators, the architect Zanstra was invited to take part in the competition.

On 24 July 1964, the design of the young Mannheim architect Helmut Striffler was chosen for the church. Striffler (born in 1927, that is, a member of the "anti-aircraft auxiliary generation", child

soldiers in WWII) had studied at Karlsruhe Technical University under Egon Eiermann (1904–1970) and Otto Ernst Schweizer (1890–1965), worked on Eiermann's St. Matthew's Church in Pforzheim and was already known for his emblematic folded-plate churches in Mannheim and for his concrete church/parish room groups (Trinitatis-kirche, Versöhnungskirche Rheinau, Kirche auf der Blumenau).

In the Dachau competition, he won convincingly against well-established Protestant church architects; to name only two, Dieter Oesterlen (1911–1994) and Egon Eiermann, who designed a group of buildings with illuminated honeycomb walls, planned to face the crematoria. But it was not merely a question of Striffler's masterly design. The chairman of the jury, Horst Linde (born in 1912), had made an intensive study of French concrete churches; and in the 1960s there was criticism in many quarters of a rigid functional approach to building, as a result of which there were an increasing number of organic and expressive spatial solutions with folded-plate roofs. It appeared that Striffler's plan was too large, and so after intensive discussions, in particular with auxiliary bishop Neu-häusler, its height had to be reduced by 50 cm. The pre-construction drawings were ready in February 1965.

The foundation stone of the Church of Reconciliation was laid on 8 May 1965 (one day before the opening of the Concentration Camp Memorial Site) by Kurt Scharf; he was assisted by the former Dachau inmates Ernst Wilm and Dirk de Loos. Donations came from all Protestant churches in Germany, but the Protestant churches in the Netherlands, France, Poland and Czechoslovakia also collected for this building project. In his call for donations on 9 November 1963, Wilm also mentioned the failure of the Protestants in the National Socialist period and regretted that, despite efforts in this direction, it had not been possible to achieve a common, supra-denominational memorial site in Dachau. In a call for donations in 1964, Kurt Scharf, the chairman of the EKD council, cited purification from sin and the prospect of reconciliation as motives for the building of the church. According to a resolution of the EKD, the Church of Reconciliation was built as a memorial for all victims of the National Socialist dictatorship and as a "monument to reconciliation and peace". A call for donations published in about 1967 states: "The church is intended to help ensure that a visit to such a place of

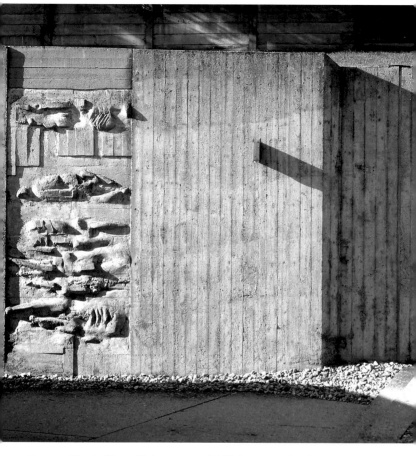

Protestant Church of Reconciliation, concrete relief (Hubertus von Pilgrim)

horror does not only cause shock, but also awakens awareness and a heightened readiness for reconciliation and responsibility for all humanity".

The Church of Reconciliation was dedicated on 30 April 1967 by the Protestant Bishop of Bavaria and new Chairman of the EKD Council, Hermann Dietzfelbinger (1908–1984). In his address, Kurt Scharf said that God had heard the supplication and prayers from

the concentration camp and helped many: "God forgives sin, even if it is terrible". In his sermon, Martin Niemöller (1892–1984), a "special prisoner" in the Dachau concentration camp and co-author of the Stuttgart Declaration of Guilt, referred to the National Socialist responsibility, but also to contemporary crises. He emphasised that reconciliation could not be awaited passively, but (following the model of Jesus) had to be actively striven for.

Since its dedication, the Church of Reconciliation has been a place of commemoration, conversation, worship and also sanctuary. Until 1978, the former Dachau prisoner Christian Reger (1905–1985) was the priest here, and from 1981 to 1984 Hans-Ludwig Wagner (1913–1993), who was persecuted under National Socialism by reason of his Jewish ancestry. During a hunger strike, Sinti and Roma were offered shelter, and the monument to the homosexual victims of Dachau was given its first temporary home here.

Design and architecture

Like the designs of Nandor Glid for the International Monument on the roll-call square (1959, 1965) and like the Jewish Memorial (plans from 1962 on), the Church of Reconciliation is sunk into the ground of the Dachau camp. This was influenced by Helmut Striffler's war experiences: the fear of death if there is no cover or roadside ditch to hide in. At the same time, there is a reference to "sinking for shame" and the desire for protection. Indirectly, such gestures represent the criticism of the traditional appearance of monuments made by the younger generation of that time. In addition, since the end of the 1950s and beginning of the 1960s, the discussion on the role of the churches in the »Third Reich« had taken on a new quality. Monumentality therefore seemed out of place.

The Church of Reconciliation is a series of rooms that are passed through as if on a path. For Striffler, architectural form and physical experience of space are parallel: "The buildings are not merely physically present, but they are involved like partners in all activities and events". The architect is convinced "that outwardly

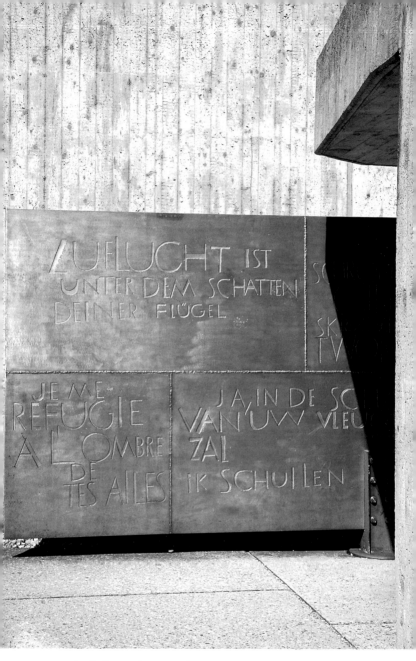

Protestant Church of Reconciliation, swivel steel gate in courtyard (Fritz Kühn)

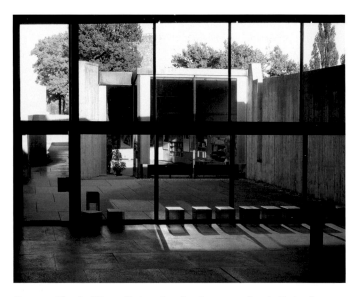

Protestant Church of Reconciliation, view of conference room from inside church across courtyard

achieving stasis is the precondition for consciousness and prayer". The building avoids right angles, demonstratively rejecting both the functionalists' insistence on geometry and the architecture of the Dachau concentration camp. Striffler said: "After so much abuse of right angles, I felt it was impossible to use them for a building in the camp. At first, I thought it would be totally impossible to create a building without being drawn into the use of these right angles. The church that was to be built there had to be without any monumentality, but at the same time to overcome the primitive regularity of the camp world. The form of the Church of Reconciliation is therefore an answer, a counterpole to all the installations of terror. It is dug into the merciless surface of the camp as a living track, as a sheltering furrow against the inhumane exposure which one senses again and again even today if one walks through the camp".

After his very first inspection of the site, Striffler felt that such a building should look, "far removed [...] from everything that a church usually is". His sketches of that time already show the

outlines, but without the exit at the west. The church as built has two continuous walls of rough-shuttered exposed concrete. These walls curve outwards in different directions and thus create contours on the site, and corridors and rooms (whose ceilings are wood-cladded steel girders). The architect believed in the "dynamism of an organic shaping of rooms". These rooms are not so much circles as broken polygons: this is connected with the Striffler buildings mentioned above in the Mannheim conurbation and with other "neo-Expressionist" concrete churches of this period.

The architecture of the north concrete wall of the Church of Reconciliation points towards the Mortal Agony of Christ Chapel; Striffler would have liked this to be more emphasised. The wall virtually grows out of the ground, in a similar way to the Friedenskirche at Manching. Coming from the camp road, visitors first encounter a welcoming, funnel-shaped entrance with stairs leading

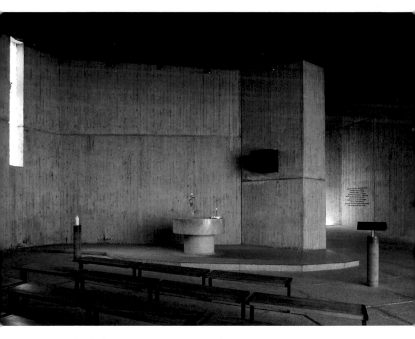

Protestant Church of Reconciliation, general view of the interior

down. They pass an oppressive narrowing area; the concrete slab above projects across the passage, but despite this an accompanying crevice of light remains, showing the way ahead. The visitor then reaches an almost rectangular courtyard. At the north and the south rise high concrete walls, overlooked only by the sky. Room-width glass and steel walls, which can be raised, give access to a shallow conference room at the east and a plain church with only a few benches and a circular altar at the west. The aesthetics of the rough-shuttered grey concrete walls is visible throughout.

The use of the conference room is flexible, it contains book-shelves integrated into the walls and surfaces for display, and it is used as a winter church. As in St. Antonius in Basel and in the Ronchamp chapel, the ground slopes steeply down. The room is normally used facing east. Sometimes, for example on Christmas Eve, the arrangement of the individual seats is rotated by 180 degrees. Then there is a view across the starlit courtyard into the church, which is sparsely lit by a tree and candlelight.

On special occasions, the church interior can be opened to the courtyard by sliding doors. It comprises a zone for visitors, in the direction of the west exit, and the area for prayer proper, which widens out like a bay. The juxtaposition of the two functions sometimes results in irritation during services. In dialogue with the Ronchamp chapel, the seating was placed diagonally in the room. The priest can adapt his position to the number of the congregation, and the circular altar is the obvious centre when Communion is administered. Protestant Christians from Poland donated the altar candlesticks, the Dutch the Communion vessels and the organ, the Czechoslovakians the lectern, the German Protestant free churches the altar.

Inside the church, the concrete floor rises again. The way to the west exit is accompanied by the words of Psalm 130: "Out of the depths have I cried unto thee, O Lord. Lord, hear my voice: Let thine ears be attentive To the voice of my supplications. If thou, Lord, shouldest mark iniquities, O Lord, who shall stand? But there is forgiveness with thee, That thou mayest be feared. I wait for the Lord, my soul doth wait, and in his word do I hope."

The rising architecture of the Church of Reconciliation reaches its highest point to the west of the church interior. At this point

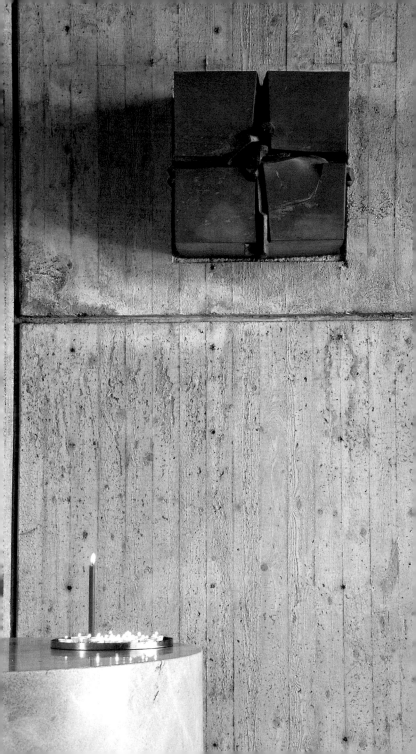

there is also a small baylike bell chamber. Some visitors find it jarring that the building rises to the crematoria but is closed off at that point; but the path to the west across the Würm canal was only laid out in 1965.

Works of art in the Church of Reconciliation

In the Church of Reconciliation, architecture and the fine arts unite, mutually enriching each other, achieving a heightened effect, very much in the sense of Richard Wagner's vision of the Gesamtkunstwerk. However, it is worth first experiencing the effect of the spatial sequences and then walking through again to consider the works of art separately. How was it possible and defensible to give artistic expression to the immeasurable suffering and death in the concentration camp – in an abstract and symbolic way, or with drastic realism; in works attached to the wall or freestanding; with reference to the fate of an individual prisoner or to the whole camp community?

In the narrowing entrance section of the church, there are wall-height concrete reliefs cast at the time of the building. For this purpose, plaster moulds were set in the concrete formwork. They are by Hubertus von Pilgrim (born in 1931), a pupil of Bernhard Heiliger, known for his death march monuments, created from 1988 on. The concrete reliefs are intended to recall the fate of the concentration camp prisoners murdered here. Inspired by the art of the catacombs and by Stefano Maderno's St. Cecilia in the church of St. Cecilia in Trastevere in Rome, von Pilgrim modelled supine figures. Their appearance changes depending on the hour of the day and the position of the sun. They are suggestions of human forms, impressions of human fates.

Between the darkness in the corridor and the light in the courtyard stands the pivoting steel portal by Fritz Kühn (1910–1967). The internationally known East Berlin sculptor, artist blacksmith and photographer had earlier worked for the Buchenwald and Ravensbrück memorial sites. A quotation from Psalm 57 is engraved

Protestant Church of Reconciliation, detail on west entrance

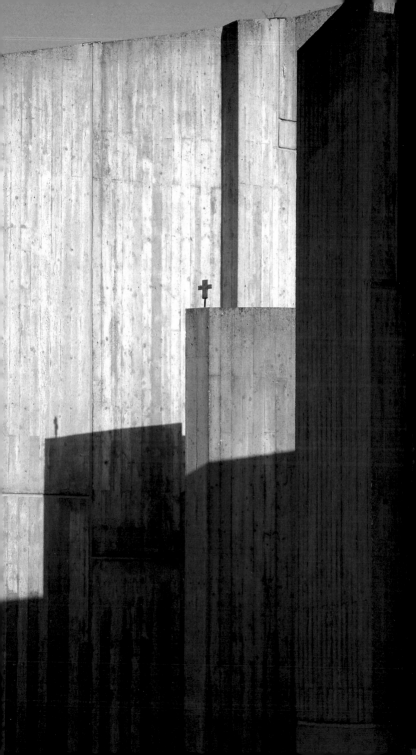

in four languages: "Yea, in the shadow of thy wings will I make my refuge". Like the secondary gateway at the west, this was a donation from the Protestant churches of the German Democratic Republic.

In the church itself, a bronze cube projects from the plain concrete wall behind the altar – the cross by the sculptor and university lecturer Fritz Koenig (born in 1924). It derives from his slightly earlier bronze sculpture Kreuz VI (Cross VI). An anthropomorphic form breaks out of the cube, which is split open with massive energy in the form of a cross. One senses that violence does not have the last word. Helmut Striffler expressed the hope that this cross would help satisfy the need for meditation. In 1983, Fritz Koenig also created the monument of the Federal Republic of Germany at the Mauthausen concentration camp memorial site.

On the opposite side of the church interior, a narrow opening, constructed of cubes of thick cast glass, attractions the attention. It is a non-representational, bright manifestation of light, a shining wall. The accentuated red area might represent a drop of blood, the symbol of both death and life. Appropriately for the glass technique used here, this is a donation of French Protestants. The design was by the painter from Trossing, Emil Kiess (born in 1930), a pupil of Willi Baumeister. The work was carried out by the internationally known glass studio Loire in Chartres.

In the entrance area of the conference room is a slender bronze sculpture, a donation of Dutch Protestants. "The three Hebrews in the fiery furnace" is a 1965–66 work by the Amsterdam sculptor and art professor Carel Kneulman (1915–2008). Kneulman had first competed to make the cross in the church. The Biblical events (Daniel 3) are here put in relation to the suffering and death of the prisoners in the concentration camp. Kneulman described this as follows: "The bodies of the youths and the flames form an unshakable vertical, a symbol of reliance on salvation. The sculpture is like a cry for truth and love and stands like an eternal flame between heaven and earth".

The building and its influence

The Dachau Church of Reconciliation is quite rightly regarded as a pinnacle of postwar church architecture in Central Europe. There were objections only with regard to the "equivocation between secular asceticism and religious inwardness" (Gerhard Ullmann) and the »exculpating aesthetics of the building« (Heino R. Möller). Even the exposed concrete was not received here with the usual vilification, which in most cases merely shows that the commenters have not mentally arrived in the modern period. Thus, for example, the theologian Rainer Volp (1931–1998) accompanied his discussion of the Church of Reconciliation with robust social criticism: "Dachau is the protest against the forgetfulness of those who do service to the right angle in neo-Classicism."

The Church of Reconciliation had no architectural successors, but this is explained by its specific architectural situation. But the architects of the new Dresden synagogue entered into a creative dialogue with the main work of their teacher. Those who experience Helmut Striffler in his Church of Reconciliation sense how strongly the dialogue with this place can mark people. Striffler says: "In my life and work, there is a stage before Dachau and a stage after."

Protestant Church of Reconciliation, sculpture in conference room
(Carel Kneulman)

THE JEWISH MEMORIAL (1967)

A t the time when the Dachau concentration camp was liberated, a military rabbi was given the opportunity to speak to the Jewish camp inmates. At the beginning of 1959, the International Dachau Committee (CID) planned churches and a Jewish memorial site on the Dachau roll-call square. Soon, anti-Semitic incidents shook the Federal Republic, which once again showed the need for a national policy of German history. But Anne Frank's diary, the Eichmann trial and the Frankfurt Auschwitz trial (both of which occurred at the same time as the planning of this memorial site) greatly intensified the Germans' interest in the

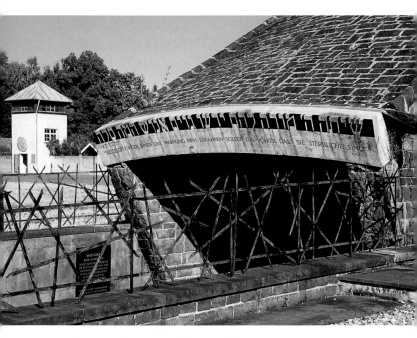

Jewish Memorial, inscription and grating in the entrance area

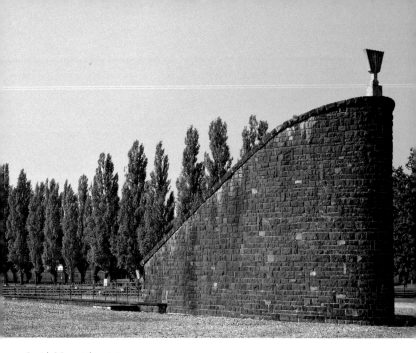

Jewish Memorial, exterior

fate of their Jewish fellow-citizens. The Jewish interest in creating architecture to commemorate the Shoah was growing at that time too.

In 1960, the first plan was to install a simple Star of David in the Dachau camp. Another idea considered was to place columns with cross and Star of David around the Mortal Agony of Christ Chapel. At the end of 1960, the Bavarian Association of Jewish Religious Communities – and specifically its President Heinz Meier (1912–1993) and Dipl.-Ing. Stefan Schwarz (1910–1985), a former concentration camp inmate – invested great energy in building a "commemorative synagogue". Finally, it was decided to do without a synagogue, for there was no Jewish community that could have maintained the religious traditions.

The building was planned on the "meditation square" at the north end of the former prison camp, east of the Mortal Agony of Christ Chapel. The Bavarian Association was in charge of the

building of the Jewish Memorial; the building costs were paid through donations and state subsidies. In March 1961, the Frankfurt architect Herrmann Zvi Guttmann (1917–1977) was commissioned to prepare a design. This design was parabolic in form.

At that time, Guttmann was one of the most successful architects of Jewish community buildings in the Federal Republic of Germany. He had built synagogues (in Offenbach, Düsseldorf and Hannover), community centres and funeral chapels. He was a Jewish architect strongly influenced by the architecture of Expressionism; in the 1920s, Expressionism had produced several churches and Jewish funeral chapels with parabolic elevations. Guttmann used a formal syntax grounded in imagery, which linked him to the most famous German church architect of the time. In his book, mentioned above, "Vom Bau der Kirche", Rudolf Schwarz had developed a basic parabolic shape ("Sacred trajectory"); From 1953–1957 he realised this architectural concept in the Heilig Kreuz Church in Bottrop. As in the Jewish memorial at Dachau, the building in Bottrop has a parabolic elevation with plain windowless walls and an elevated source of light in the apex. Guttmann saw the parabola as a figure of tension, both of physical and mental forces. "I see the parabola as a symbol of this striving forward or upward, whose apex points to the resistance of mere human striving against divine infinity". With regard to the light entering from above, the architect may also have studied the memorial plans for the former concentration camps of Auschwitz-Birkenau and Neuengamme.

A set of plans by Guttmann for the Dachau building bears the date 30 March 1962; on 9 November 1962 the concept of the Jewish Memorial was discussed by reference to a model. In Guttmann's original plan, the building was 7–8 m further east, nearer Alte Römerstraße, and approximately one-quarter larger. At the request of the CID, this plan was amended. A planned glass and concrete section in the ceiling area was also dispensed with.

The foundation stone of the Jewish Memorial was laid in early summer 1964. The building inspection was carried out by Dipl.-Ing. Theodor Klotz (Dachau); the shell was already complete in May 1965. Now there began the selection of the texts for the inscriptions; there was a discussion here as to whether these should be of

Jewish Memorial, general view of the interior

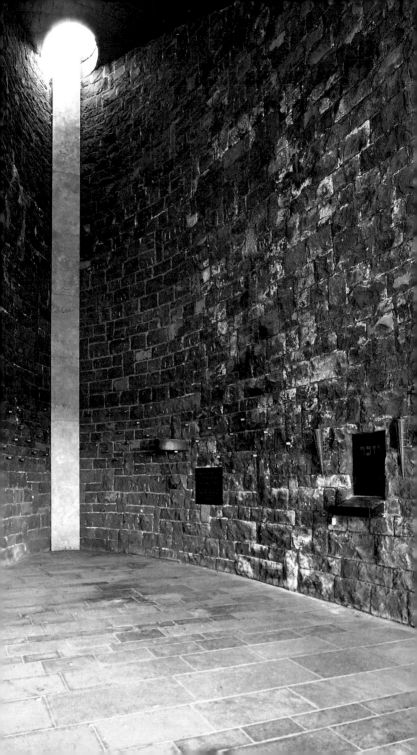

a generally admonitory character or whether they should contain a message referring explicitly to the Shoah. The building process was delayed for financial reasons, and eventually the Jewish Memorial was ceremonially dedicated on 7 May 1967 – 5727 according to the Jewish calendar: rabbis lit the sanctuary lamp. The respected Fürth rabbi David Spiro (died in 1970), who himself had suffered in Flossenbürg and Dachau, thanked God on behalf of those rescued from the concentration camps. Spiro also thanked the Allies. He said they had been the heavenly messengers and mediators of this rescue. He vowed that the victims would not be forgotten, for they were "part of our broken nature".

As the inscribed plaque to the left of the entrance puts it, in Dachau a "monument to the memory of the Jewish martyrs" of the years from 1933 to 1945 was to be built. In the narrow sense, this monument (matzevah) is for the Jews murdered in the Dachau concentration camp. The deed of dedication reads as follows: "The Dachau memorial site shall for all times remain a memorial and a warning! Every year, we will pray for our dead and commemorate them here". As the presidents of the Bavarian Association emphasised in 1967 and 1972, this memorial is also for all victims of the Shoah. "The thousands who are buried in this spot symbolise for us the millions who met their tragic end in Auschwitz, Treblinka, Majdanek and many other places" (Simon Snopkowski, 1925–2001).

Form and statement

The Jewish Memorial stands near the eastern row of former barracks and its entrance faces it. From some distance, it has the appearance of an erratic block. On the other hand, the greatly elongated parabolas of the ground plan and the roof area, which rises diagonally to the north and is gently curved, create a perceptible dynamism in the structure. If one walks around the Memorial, its appearance goes through great changes: seen from the sides, broadly squatting; at the north, towering like the bow of a ship; on the entrance side, unstable and introverted. Light plays a big role in its sculptural effect.

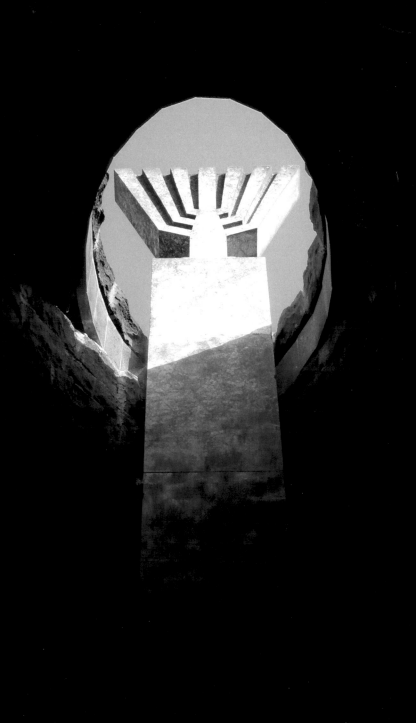

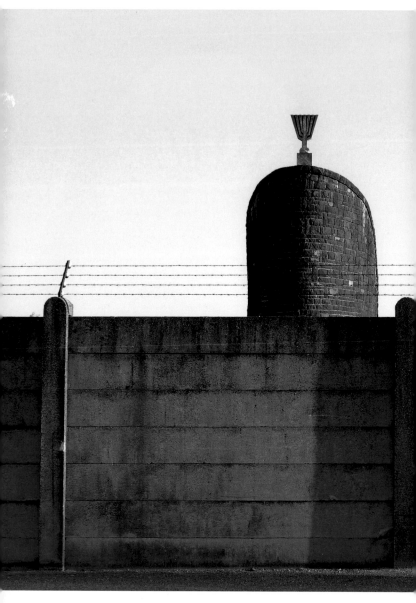

Camp wall and Jewish Memorial

The memorial is 10 m wide, 15 m long and 9 m high. It is probably not a solid construction, but a concrete or concrete skeleton construction, cladded on both sides with quarry-faced rusticated dressed scoria. In this way, the basalt slab floor, the walls and the concrete ceiling, the outside of which is faced with stones, form a material unity. This too gives the structure an organic character. Access is by an 18 m long, straight ramp, which descends by a total of 1.80 m. The building is therefore sunk into the ground, and in this eloquent sign, which may have come about in reflection on Psalm 130 (De profundis), similar to the Protestant Church of Reconciliation and the International Monument on the roll-call square.

The formal structure of the Jewish Memorial was an attempt to convey the sufferings of the Jews in the National Socialist era *(architecture parlante)*. For example, the sunken ramp-like entrance and the dug-in nature of the building are references to the life in hiding places and underground cellars, to the ramps in the extermination camps, and perhaps also to the way to the gas chambers. The iron gratings along the descending passage and on the entrance gate are a highly stylised reference to the barbed wire of the concentration camp. Equally important is the warning note of Psalm 9:20, which is chiselled into the end of the building above the entrance in Hebrew and German. "Put them in fear, O Lord: That the nations may know themselves to be but men". The first impression on entering the room is that it is oppressive and dark. This results from the narrow, elongated parabola form of the ground plan and the plain, windowless walls of dark grey scoria.

The right-hand wall deliberately faces east; against it is a small lectern of black granite. Here, the mourners' kaddish is spoken. Immediately above it, a plaque is set into the wall, with the single, decisive word: Jiskor (yizkor) – Remember! Adjoining it are conical torch holders, nearby the sanctuary lamp and a commemorative plaque for the six million Jews killed. The seventy candleholders set into the wall for the ceremony on the Day of Remembrance represent the seventy Elders of Israel (Numbers 11:16).

The purpose of the building is to commemorate the dead, but it is also intended to give the survivors strength to hope. On the entrance grating, two olive branches formed into doorhandles

symbolise the hope of a flourishing, beautiful Israel, with reference to Hosea 14:6–7. Once the visitor has passed the squat, oppressive segmental-arch entrance area, the slightly arched ceiling of the building rises steeply in the line of vision. At the apex of the room, a marble band similar to a pilaster strip leads towards the light, up through a circular ceiling opening to the seven-branched candelabrum, the menorah. This is highly stylised and stands at the highest point of the place of prayer and commemoration. "The light of hope [is] deeply rooted in Judaism [...]. At the end of this hope stands redemption – the eternal Jewish existence is here symbolically expressed by the seven-branched candelabrum against the background of the sky" (Hermann Zvi Guttmann). The memory of the Promised Land is also expressed substantively here: the pilaster strip and the menorah are of marble from Peki'in in Israel. This high-quality stone was quarried in a place that is said to have been inhabited by Jews without interruption. It represents the continuity of Judaism.

THE RUSSIAN ORTHODOX RESURRECTION CHAPEL (1995) – A LATER PLACE OF COMMEMORATION

The history of the chapel

As a result of the developments in world politics, there has been increased interest in the fate of the concentration camp victims from the former Soviet Union since 1991. The main emphasis was on the documentation and the ideological assessment of their suffering. Soviet prisoners former the second-largest national group in the Dachau camp.

The occasion for the building of the Resurrection Chapel was the finding of lists of names of the Orthodox prisoners in Dachau and the awareness that here and in the other concentration camp memorial sites in Europe there was as yet no memorial site for the Orthodox Christians who had died. The initiative came from Gleb Rahr (1922–2006), a former Dachau inmate who was active in church politics, and from Archbishop Longon von Klin (born in 1946), the permanent representative of the Russian Orthodox Church in Germany; Patriarch Alexy II (1929–2008) and the Embassy of the Russian Federation also took up the subject. After the plot of land in Dachau was purchased with the assistance of the Bavarian authorities, first of all a wooden cross was installed there. The chapel building itself was a Russian donation, and the design was by the architect Valentin Utkin. The chapel construction system was produced in the Vladimir area and pre-assembled on a trial basis there, and then the individual sections were brought to Germany by lorry. Soldiers with building experience were chosen from the last units of the Russian forces stationed in Germany; these came to Dachau in August 1994 and built the Resurrection Chapel. Its ceremonial dedication took place on 29 April 1995 – on the fiftieth anniversary of the liberation of the Dachau concentration camp. The chapel was consecrated by Metropolitan Nikolai of Nizhny Novgorod and Arsamas, a former officer and frontline soldier. Since September 1996, services have been held in the Resurrection Chapel on special commemoration days.

The building

I f one leaves the Church of Reconciliation to the west, going towards the memorial area of the crematoria, then on the other side of the bridge across the Würm Canal a path turns off to the left; this leads to the Russian Orthodox Resurrection Chapel. It is outside the former prison camp on a quiet, tree-covered meadow. The chapel is set at a slight elevation; some of the earth in this bank is from Russia.

The Resurrection Chapel is an octagonal centrally planned wooden building. At first glance the influence of Russia's traditional architecture is evident. This applies to the steep tent-like form (customary in North Russian cemetery churches), the lantern, clad with wooden shingles like scales, the Russian cross and the striking log construction. In this construction method, which is also used in the Alps and in Scandinavia, large logs are laid horizontally on top of one another; at the corners, the cross-sections of the logs protrude to form the characteristic corners. In order to create this effect, the notches in the logs have to be carefully measured. As can be seen in this building too, the joints of the round logs are sealed with coarse material. The interior of the Resurrection Chapel is characterised up to the apex of the building by the wood of which it is made, and is richly furnished.

The liberation of the prisoners as the experience of Easter

A plaque attached to the exterior states that the Resurrection Chapel is a memorial to the Russian fellow-citizens who died in the National Socialist concentration camps. This probably refers to the prisoners who lived in the former Soviet Union. When mass is celebrated, all Orthodox Christians who died in Dachau and in other places of suffering are commemorated. Particular mention is made of the 1945 Easter service. Shortly after the liberation of the Dachau concentration camp, on 6 May 1945, the former Orthodox prisoners celebrated Easter in the camp chapel in

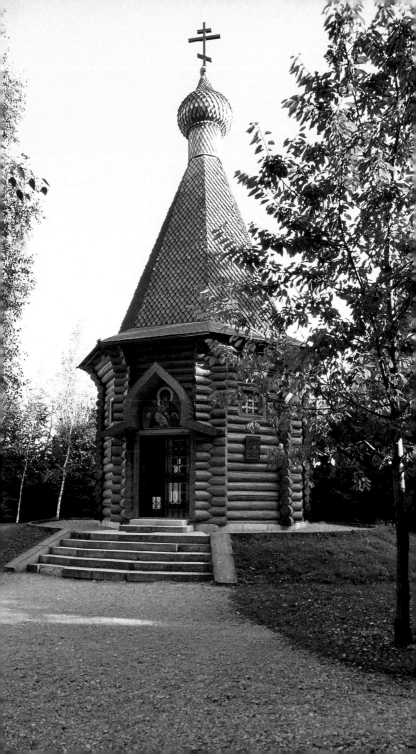

Russian Orthodox Resurrection Chapel, detail of log construction

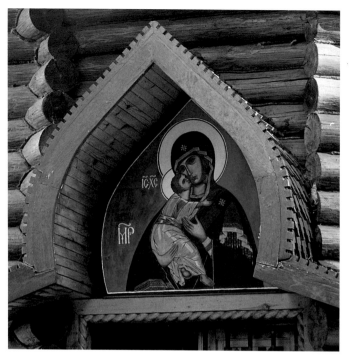

Russian Orthodox Resurrection Chapel, Madonna and child above the entrance

Block 26. Very fittingly, Easter coincided in this year with St. George's Day (which explains the presence of a large icon showing St. George victorious).

The iconography of the main icon behind the altar also refers to this Easter event. The large panel, painted in tempera by the Bonn icon painter Angela Heuser (born in 1950), shows the watch towers of the concentration camp now unoccupied. Two angels have opened the camp gate wide and Christ, radiantly shining as Resurrected, leads the prisoners to freedom. The artist says that this referred to all the concentration camp inmates, that is, also those who did not suffer the tortures in the camp. The red triangles on their clothing show that almost all of them are political prisoners.

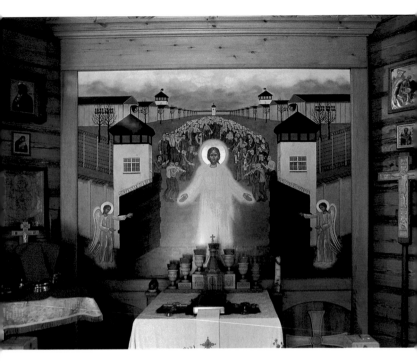

Russian Orthodox Resurrection Chapel, altar with main icon (Angela Heuser)

Among those at the front of the procession of prisoners, near Christ, stand two Orthodox priests in prisoners' garb. They can be recognised only by their bright epitrachelion (stole) with red crosses; during the service after liberation, these consisted of towels and Red Cross packaging material. The icons above the inner chapel entrance show saints whose feast days are connected with the invasion by the National Socialist German Reich of the Soviet Union (22 June 1941). In this way, the beginning and end of the Second World War are inscribed on the central room of the Resurrection Chapel as an axis of time and imagery.

HISTORY, REMEMBRANCE AND THE PRESENT DAY

"If a miracle should come to pass and you escape with your lives, write it down and speak about what they did to us."
(Words of a dying inmate in Dachau)

"[The life of the victims in Dachau] has left a track which we encounter again and again and which we cannot pass by."
(Helmut Striffler, architect, 1967)

"May these memorials help to ensure that never again will a Cain raise his hand against his brother Abel." (Senator Jean Mandel on the religious memorials in the Dachau camp, 1967)

"The past is never simply the past. It always has something to say to us; it tells us the paths to take and the paths not to take. [...] All these inscriptions speak of human grief, they give us a glimpse of the cynicism of that regime which treated men and women as material objects, and failed to see them as persons embodying the image of God." (Address of Pope Benedict XVI in Auschwitz, 2006)

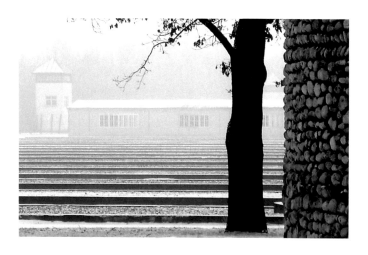

Björn Mensing, Enikö Peter OCD and Ludwig Schmidinger

CHURCH MEMORIAL WORK IN DACHAU

"… in order that inhumanity, lack of freedom and injustice do not again come over humanity, but instead the realm of truth and of life, of holiness and mercy, of justice and love and of peace."

These words were written by the former concentration camp inmate Johannes Neuhäusler as a Catholic auxiliary bishop on 14 July 1960, shortly before young people went on a pilgrimage from Munich to the former Dachau concentration camp in order to take part there in the dedication of the Mortal Agony of Christ Chapel on 5 August 1960.

For the churches and for all of the public, this dedication was a powerful signal that commemorating the victims of the National Socialist dictatorship and advocating and ensuring a just society must have a definite and important place in the public consciousness not only of the churches but of society as a whole. This signal was magnified in the following years by the further religious memorials in and adjoining the Concentration Camp Memorial Site.

The process of critically coming to terms with church involvement in National Socialism was stated to be part of their work, in particular by the Protestants. The former inmate of Dachau Martin Niemöller, as a church president in the postwar period, said:

"When the Nazis came for the Communists, I did not speak out, because I was not a Communist. When they locked up the Social Democrats, I did not speak out, because I was not a Social Democrat. When they came for the trade unionists, I did not speak out, because I was not a trade unionist. When they came for me, there was no-one left to protest."

And this is the text of the preamble of the Order for the Church of Reconciliation: "The legacy of guilt, conformity and resistance in National Socialism and the memory of this give the Church of Reconciliation an unmistakable character. As a place of dialogue with

*60th anniversary of the liberation of Dachau concentration camp on 1 May 2005;
front, from left: Reverend Nikolai Zabelitch (Orthodox), Friedrich Cardinal Wetter
(Catholic), Chairman of the EKD Council Bishop Wolfgang Huber (Protestant)
outside Block 26*

the history of German Protestantism under National Socialism, in
ecumenical cooperation, it serves to awaken consciousness of the
responsibility of Christians for a humane future."

From the beginning, the Dachau memorials have concentrated
on the memory of the victims and on their dignity, and this em-
phasis led to the appeal that we should question present-day
circumstances and should be more vigilant against abuse and
show more support for human rights – expecially when encounter-
ing the resistance of society as a whole, not infrequently even from
church circles.

The cry "Never again", made in response to the need or even the
demand for a final line to be drawn, not only was a reminder that

the past cannot be undone and cannot simply be repressed, for the simple reason that it continues to have an effect, whether or not we will; it also created a signal and a standard for the future which no-one would be able to ignore.

Fifty years have now passed since then, and in that period the church institutions that are represented at the Concentration Camp Memorial Site have held a large number of events and have been continuously present, and in this way they have helped to carry forward this signal and this message. These developments will be set out here.

All this work is carried out through cooperation between the Catholic and Protestant institutions whose representatives are present on the former concentration camp site; this reflects the importance of ecumenism for the work in this place. For in the concentration camp itself, Christians among the inmates were already overcoming the old denominational barriers. For many of them, shaped by centuries-old mutual prejudices, it must at first have been an uncomfortable experience to be locked in one priests' block by the Nazis together. We known from the published memories of some of them how hard it was for them to bear the shared use of the chapel in Block 26. But there is a great deal of evidence of a genuine ecumenism among the inmates. Together with the Catholic clergy, the Protestant pastors held a short worship session in the dormitory every evening. The Protestant Ernst Wilm records that it "was held on weekdays by a Catholic clergyman – who usually spoke on the legend of a saint – and on Sunday by a Protestant minister – this was perhaps a report from the struggle of the Confessing Church with the state or of pastoral work … or an interpretation of the scriptures – and it ended with all reciting the Lord's Prayer together". However, ecumenical services were unconceivable. Nevertheless, the shared experience of confinement gave a new sense of connection. Eugen Weiler, a Catholic, remembers: "In the chapel in the Dachau concentration camp, the Catholic priests, the Protestant and other fellow-Christians had a good relationship with each other". Max Lackmann, a Protestant, writes in very similar terms: "As comrades – and in a certain sense as belonging to a category of convinced Christians and opponents of Nazis – we had a good brotherly relationship." A highlight of ecumenism was the feast on

Renée Lacoude (right), a Dachau survivor, at the presentation of her biography for the Book of Remembrance project "Names instead of Numbers" in the Carmelite convent (22 March 2005)

the occasion of the secret ordination of Karl Leisner in Block 26, described touchingly in a report: "In the third room of the block there is a moving ecumenical meeting. The Protestant pastors have prepared a meal for Leisner [a Catholic], and in this place that means a sumptuous feast. They showed complicity for a good purpose , inventiveness and cunning to lay this table, which was intended for Bishop Piguet and the priest Karl Leisner: white table-cloth, porcelain, coffee and pastries. An hour of close companion-ship with our Protestant brethren!" Friendships developed between Christians of different denominations. For example, throughout his life the Protestant parson Martin Niemöller had a close friendship with his Catholic fellow-inmate Michael Höck.

The resistance fighter Marie-Luise Schultze-Jahn (follow-up group to the White Rose group) at a reading in the courtyard of the Church of Reconciliation (18 July 2006)

The words of Christ from the gospel of St. John, "That they all may be one" took on a quite new significance for many of those present. But what succeeded on the interpersonal level of comradeship remained arrested in its beginnings when it came to joint religious services and a rapprochement of the denominations. Eugen Weiler, a Catholic, summarises with disappointment: "But it apparently did not go further than a few outward points of contact." It was too little for him: "Can the shedding of so much blood in Dachau and elsewhere have been in vain?"

Like Weiler, other Christians in the Third Reich also suffered from the division of Christendom. For many of them, the words "that they all may be one" – often in the Latin version "ut (omnes) unum sint" – became virtually a motto and the leitmotif of their ecumenical commitment. After liberation, many of the inmates of the priests' block became pioneers of the ecumenical movements within their churches.

Even if there are some difficulties, we wish to remain faithful to the legacy of the priests' block. But Christ does not leave us alone with this great mandate. He intercedes with his heavenly father for us too when he prays: "that they all may be one", "that the world

may know that thou …hast loved them, as thou hast loved me." (John 17:23)

The Concentration Camp Memorial Site has become not merely a place of commemoration and learning, but also, and here specifically its churches, a place of encounter – in more than one way:

Visitors, whether coming individually or in a group, encounter here not only the history of the years from 1933 to 1945, but above all the stories of people and of their fates.

In this process, visitors often encounter themselves in a new manner, whether because in tracing their relatives or forebears they become aware of part of their own history, or whether because they discover something that till now was unknown and unfamiliar to them, and indeed may, because it is incomprehensible, be experienced as disturbing and frightening.

And visitors encounter the place with its authentic testimony and various memorials and monuments – as they are presented in this book.

In all these encounters, visitors who are religious, and in particular Christian, are confronted with the question of humanity and the question of God: What are human beings to other human beings? What is a human being in the eyes of God? Where was God when all the atrocities were committed?

The churches at Dachau try to meet the demands of these various degrees of encounter – and in doing so to fulfil their fundamental mandate in a great variety of ways.

This fundamental mandate of the church includes remembering and commemorating the sufferings of those persecuted: the "memoria passionis" – the memory of Christ's Passion is the historical and substantive core of the faith handed down in the Christian creed. In the New Testament, Jesus already identifies himself with all the persecuted, oppressed and imprisoned (Matthew 25:31–46). The disciples' memory of the crucified Christ, their coming together in the feast of remembrance of the death of Jesus (which they themselves witnessed) and the belief that this very death is the precondition of his Resurrection and thus of the resurrection of all humanity, was what led to the existence of the church.

Since 1964, the **Carmelite Convent of the Precious Blood** has immediately adjoined the former concentration camp – the

present memorial site. Its founder, Mother Maria Theresia, deliberately sought this proximity. For her aim was to create a place of prayer and a sign of hope in this terrible and baleful place, to understand atonement as an act of reconciliation by receiving past and present evil into the reality of redemption of Jesus Christ.

In the church, visitors can write down their personal concerns and troubles for the nuns as a request for prayer, and they can allow their impressions from the visit to be enclosed in this place of quietness.

Today, many people seek contemplation. With its Christian tradition, the Carmelite convent may be an important dialogue partner in this spiritual challenge – by taking part in the liturgy, through writings, conversations and afternoon meditations.

And with its teaching and practice of prayer, the Carmelite convent has identified a spiritual path of contemplation which even today still addresses many people. Human beings can hold a dialogue in friendly companionship with God, can linger with God or lose themselves in his presence, for personal, inner prayer is nothing other "than association and intimate dialogue with the friend who we know loves us", writes Teresa of Avila.

The **Church of Reconciliation** is another place of meditation that is open to every visitor during the opening hours of the Memorial Site for peace and contemplation; it is also available to groups to hold their own services and silent prayer sessions. Many of the visitors from all over the world light candles as a sign of their commemoration and write down their impressions and concerns. A member of the team is usually available in the conference room to answer questions.

In the **Ecumenical Guided Tours** held by the Protestant Church of Reconciliation and the Catholic pastoral care organisation, a large number of visitors, predominantly young people on visits arranged by schools, or in connection with preparation for their confirmation, are introduced to the history of this place by the guides. The emphasis is not only on conveying the facts of history, but also, without exception, on the question of human beings and their conscience. Usually, these guided tours of the exhibition and the grounds of the Concentration Camp Memorial Site end at one of the religious memorials.

Both in the regular **services** (Carmelite Convent 9 a.m., Church of Reconciliation 11 a.m.) and also on special commemorative occasions, individual fates and historical events associated with Dachau concentration camp are again and again the central theme and are recalled with concrete details, for example in the monthly services in the Mortal Agony of Christ Chapel or during the Stations of the Cross, which is held annually one week before Good Friday on the memorial site, and which stops at chosen places to report the experiences of individual inmates.

Since 1999, the project **Book of Remembrance for Inmates of Dachau Concentration Camp**, for which a broad range of institutions are responsible, has revived the remembrance and commemoration of victims of National Socialist terror with particular urgency, and the design of the project has also particularly encouraged young people to take an interest in contemporary history. In preparing a biography for a single individual, they consider and concern themselves with a personal fate. In this way, there is a belated appreciation of the fate of many of the individuals portrayed in this way, and a recognition of their suffering. The biographies can be read at a table in the conference room of the Church of Reconciliation. An international travelling exhibition entitled "Names instead of Numbers" shows a selection of the biographies in several countries.

We are always glad to be able to welcome **contemporary witnesses** at events. Some, but not all of them, are among those portrayed in the Book of Remembrance. In conversations with groups or telling their own story, sometimes as part of ecumenical memorial services, they give later generations an authentic account of situations they experienced themselves. These meetings are particularly helpful for us to experience the importance and significance of dialogue with the past, and they emphasise the task of promoting human dignity and justice.

One possibility of a quiet presentation of various themes that arise in connection with different facets of commemorative work is provided by **exhibitions**, which are held for visitors in the conference room of the Church of Reconciliation – and these do often give an opportunity to begin conversations and thus contribute to encounters with others.

Since 1979, the practice has been for two **volunteers** from **Action Reconciliation/Service for Peace** (ARSP) to work for one year in the Church of Reconciliation and in the ecumenical team – the report of Aleksandra Kozyra from Poland, who was a volunteer in 2005/2006, gives an impression of the experiences of volunteers:

"In a sense, the Church of Reconciliation was my 'home'. It was here that the weekly team meeting took place, it was here that I carried out my service as a volunteer and was present for the visitors, who often asked me a variety of questions, sometimes on the history of Dachau concentration camp, sometimes on the exhibitions that were held in the conference room of the Church of Reconciliation, sometimes on the Book of Remembrance for Inmates of Dachau Concentration Camp that can be seen here, or quite directly: 'What is the German government doing against racism and right-wing extremism?' Here I also helped in the office, with exhibitions and events, and on Sundays I assisted as verger, and I got to know very nice people from the congregation. I even met some of them privately, and some of them invited me and the second ARSP volunteer, Ian Maloy from Wales, to dinner. A man from the congregation was born in Swidnica (Poland), which used to be part of Germany, and getting to know him and talking to him were a good counterweight to the displaced persons' association, which are active and make insisten demands, particularly in Bavaria, including Dachau."

Meetings with the contemporary witnesses, the dialogue with history and the stories of individuals inevitably lead constantly to the present and to the question of the future. This is particularly evident at the annual celebrations of the date of liberation.

In his sermon on the 60th anniversary of liberation, Bishop Wolfgang Huber reminded his listeners that "since the death of Christ" there should "never again be such sacrifices", and that "the memory of those who left their lives here (…) (makes) us feel shame over what happened then. But this memory also helps us to find standards for our own lives and despite our own weakness to adhere to them. … In the light of what happened here we know why it is important to give the glory only to God and to love our fellow-humans. … Here, again and again, we can spell out the answer to the question as to why we turn to God in prayer, why

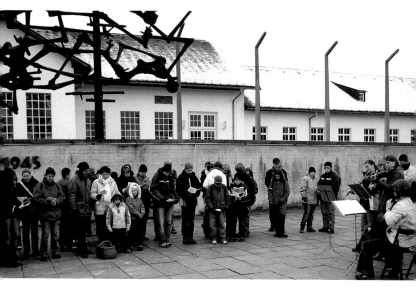

Ecumenical Prayers for Peace at the International Monument (20 November 2005)

we take in strangers, why we take care of the weakest members of our society and why we confront the memory of past injustice."

In many cases, the commemoration work is organised together with other institutions: with the Concentration Camp Memorial Site and the International Dachau Committee (CID), with Jewish partners and the Orthodox church, but also with the Dachau International Youth Hostel and the International Youth Meeting which takes place every year in summer, and at other commemorative events, with the City of Dachau or with the Round Table on Contemporary History organised by the City of Dachau. The ecumenical event Prayers for Peace in November, organised by the Bund der deutschen katholischen Jugend (Association of German Catholic Youth) and the Evangelische Jugend München (Munich Protestant Youth) also has a long tradition now.

Time and again, special projects are realised, for example an event commemorating National Socialist victims from the world of football, which reaches people who could not automatically be

encouraged to take part in a commemorative event or be sensi-
tised for action against right-wing extremism – at least not in this
connection.

Attending or taking part in events of critical research on con-
temporary history are also part of the work of memory and recon-
ciliation, for example at the annual Dachauer Symposium für Zeit-
geschichte (Dachau Symposium on Contemporary History), or in
the exchange of information with other memorial sites and staff
who work there on behalf of the churches – or in cooperation with
other educational institutions such as the Evangelische Stadtakade-
mie in Munich or the Kardinal-Döpfner-Haus in Freising.

Together with the religious services and spiritual programme,
the thematic and cultural events in the Church of Reconciliation or
in the Carmelite Convent show clearly that the churches take their
responsibility for the commemorative work seriously over and
above their work for individuals or groups, and that they also have
public influence.

We wish to work towards the goal stated in the motto of the
Second Ecumenical Church Congress 2010: "that you may have
hope", and all these endeavours are steps towards this goal, steps
to be taken in a sound and realistic way. At all events, the church
staff who work at the Concentration Camp Memorial Site warmly
invite you to join them on these paths, to share in the work and, last
but not least, to pray with them. It was for all these purposes that
the religious memorials were conceived and built.

Dr. Enikö Peter OCD
Prioress of the
Carmelite Convent of
the Precious Blood

Dr. Björn Mensing
Pastor of the
Protestant Church
of Reconciliation

Ludwig Schmidinger
Episcopal Delegate
for concentration camp
memorial site work

KZ-Gedenkstätte Dachau
Alte Römerstraße 75, D-85221 Dachau · Tel. 08131/66997-0
Opening times: daily except Monday from 9 a.m. to 5 p.m. (entrance free)
www.kz-gedenkstaette-dachau.de · info@kz-gedenkstaette-dachau.de

Evangelische Versöhnungskirche in der KZ-Gedenkstätte Dachau
Alte Römerstraße 87, D-85221 Dachau · Tel. 08131/13644
www.versoehnungskirche-dachau.de · info@versoehnungskirche-dachau.de

Jewish Memorial
Responsible body: Landesverband der Israelitischen Kultusgemeinden in Bayern
Effnerstraße 68, D-81925 München · Tel. 089/989442
www.ikg-bayern.de · info@IKGL.de

Karmel "Heilig Blut"
Alte Römerstraße 91, D-85221 Dachau · Tel. 08131/21068
Karmel.Dachau@t-online.de

Katholische Seelsorge an der KZ-Gedenkstätte Dachau
Alte Römerstraße 75, D-85221 Dachau · Tel. 08131/321731
www.gedenkstaettenseelsorge.de · LSchmidinger@ordinariat-muenchen.de

Orthodoxe Christi-Auferstehungs-Gedächtniskapelle
Gemeinde der Russisch-Orthodoxen Kirche in Deutschland
Berliner Diözese des Moskauer Patriarchats
Pfarrer Nikolai Zabelitch, Glyzinenstraße 38, D-80935 München
Tel. 089/3515742 · www.voskresenie.de

Other important addresses

Dachauer Forum e. V. [including Guided tours of the memorial site]:
www.dachauer-forum.de

Förderverein für Internationale Jugendbegegnung und Gedenkstättenarbeit
in Dachau e. V.: www.foerderverein-dachau.de

Book of Remembrance for Inmates of Dachau Concentration Camp:
www.gedaechtnisbuch.de

Dachau International Youth Hostel: www.jgh-dachau.de

Stadt Dachau: www.dachau.de

Verein »Zum Beispiel Dachau«: www.zbdachau.de

History of Dachau Concentration Camp

Benz, Wolfgang/Distel, Barbara (eds.): Der Ort des Terrors. Geschichte der nationalsozialistischen Konzentrationslager, vol. 2: Frühe Lager, Dachau, Emslandlager, Munich 2005

Distel, Barbara [and others] (adapted): Konzentrationslager Dachau 1933 bis 1945, Text- und Bilddokumente zur Ausstellung, Munich 2005

"Second" History of the Dachau Camp (1945 to Present)

Hoffmann, Detlef: Dachau, in: idem (ed.): Das Gedächtnis der Dinge, KZ-Relikte und KZ-Denkmäler 1945–1995, Frankfurt am Main/New York 1998, pp. 36–91

Hoffmann-Curtius, Kathrin: Memorials for the Dachau Concentration Camp, in: Oxford Art Journal, 21, 1998, no. 2, pp. 21–44

Marcuse, Harold: Legacies of Dachau. The Uses and Abuses of a Concentration Camp, 1933–2001, Cambridge 2001 [standard work; abridged versions in: Dachauer Hefte, 6, 1990, pp. 182–205, and in: Benz, Wolfgang/Königseder, Angelika (eds.): Das Konzentrationslager Dachau. Geschichte und Wirkung nationalsozialistischer Repression, Berlin 2008, pp. 163–180]

Eschebach, Insa: Öffentliches Gedenken. Deutsche Erinnerungskulturen seit der Weimarer Republik, Frankfurt am Main/New York 2005

Gerhardus, Sabine/Mensing, Björn (eds.): Namen statt Nummern. Dachauer Lebensbilder und Erinnerungsarbeit, Leipzig 2007

Endlich, Stefanie: Orte des Erinnerns – Mahnmale und Gedenkstätten, in: Reichel, Peter/Schmid, Harald/Steinbach, Peter (eds.): Der Nationalsozialismus – die zweite Geschichte, Munich 2009, pp. 350–377

Single Religious Memorials on the Dachau Camp Memorial Site

Neuhäusler, Johannes: Carmel "Heilig Blut" (Precious Blood) Dachau, Munich 1965

Schmidt, Doris: Der Karmel Heilig Blut Dachau. Eine moderne Klosteranlage, in: Das Münster, 18, 1965, no. 7/8, pp. 231–238

Die Evangelische Versöhnungskirche im ehem. Konzentrationslager Dachau, in: Kunst und Kirche, 31, 1968, no. 2, pp. 50–65

Schwarz, Stefan: Die jüdische Gedenkstätte in Dachau, Munich 1972

Josef Wiedemann. Bauten und Projekte. exhib. cat., Munich 1981

Bredow, Jürgen/Lerch, Helmut: Materialien zum Werk des Architekten Otto Bartning, Darmstadt 1983

Flagge, Ingeborg (ed.): Helmut Striffler. Licht, Raum, Kunst. Eine Ortsbestimmung, exhib. cat., Mainz 1987

Pfister, Peter: Zeuge der Wahrheit. Johannes Neuhäusler, Dachau 1988

Remmlinger, Sophie/Hofmann, Klaus (eds.): Hermann Zvi Guttmann. Vom Tempel zum Gemeindezentrum, Frankfurt am Main 1989

Schmitt, Veronika Elisabeth: Karmel – Weg in Innenräume, Würzburg 1994

Ullmann, Gerhard: Tatorte, Gedenkorte. Versöhnungskirche, Dachau, in: Dechau, Wilfried (ed.): … in die Jahre gekommen, Teil 3, Stuttgart 1998, pp. 89–94

Flagge, Ingeborg (ed.): Helmut Striffler Architekt, Fotograf Robert Häusser, exhib. cat., Hamburg 2002

Kohnert, Frauke: 50 Jahre Otto-Bartning-Kirchenprogramm, Geeste [2]2003

Richardi, Hans-Günter: Die Gründungsgeschichte der Dachauer Gnaden- kirche im Wohnlager Dachau-Ost, in: Amperland, 41, 2005, no. 1, pp. 1–5

Seeger, Hans-Karl/Latzel, Gabriele: Der Dachau-Altar in der Lagerkapelle des Konzentrationslagers, Emmerich 2005

Backmeister-Collacott, Ilka: Josef Wiedemann. Leben und Werk eines Münch- ner Architekten 1910–2001, dissertation Munich 2005, Tübingen 2006

Schultze, Harald: Märtyrerdebatten in der Evangelischen Kirche in Deutsch- land (EKD) zwischen 1945 und 2000, in: Kirchliches Jahrbuch, 133, 2006, pp. 217–274

Blundell Jones, Peter/Canniffe, Eamonn: Modern Architecture Through Case Studies, 1945–1990, Amsterdam [and others] 2007, pp. 89–100

Durth, Werner: Transformation der Erinnerung, in: Kramm, Rüdiger/Schalk, Tilmann: Sichtbeton. Betrachtungen, Düsseldorf 2007, pp. 37–44

Stock, Wolfgang Jean (ed.): Gegen das Vergessen – Kunst und Geschichte, exhib. cat., Munich 2007

Archives Consulted

Archives of the Archdiocese of Munich and Freising/Archiv des Erzbistums München und Freising (Papers of Cardinal Faulhaber, Papers of the General Vicariate)

Archives of the Dachau Concentration Camp Memorial Site/Archiv der KZ- Gedenkstätte Dachau

Archives of the Church of Reconciliation, Dachau/Archiv der Versöhnungs- kirche Dachau

Collection of the architecture museum of Munich Technical University/Sammlung des Architekturmuseums der TU München (Papers of Josef Wiedemann)

Front cover: Church of Reconciliation on the Dachau Concentration Camp Memorial Site, entrance area and gate

Inside front cover: Aerial photograph of the religious memorials at the north of the Dachau Memorial Site (2009)

DKV Edition
Dachau Concentration Camp Memorial Site. Religious Memorials

This publication was supported by Evangelisch-Lutherische Kirche in Bayern with the »Auf dem Weg zum 2. Ökumenischen Kirchentag 2010« funds and by

▼▲■ Verein Ausstellungshaus für christliche Kunst e. V.

Illustrations:
All illustrations by Kai Kappel, Berlin (2007 and 2009)
with the exception of
Inside front cover, page 23, 25: © www.Luftbild-Bertram.de
Page 14 (Photo Jean Brichaux), 16, 18: Archiv der KZ-Gedenkstätte Dachau
Page 20: Archiv der Evang. Gnadenkirche Dachau-Ost
Page 39, 47 (Photo Erika Drave): Architekturmuseum der TU München
Page 50: Archiv Prof. Helmut Striffler, Mannheim
Page 83, 86, 91: Archiv Versöhnungskirche, Dachau
Page 85: Collection Renée Lacoude, Bordeaux
Inside back cover: Ludwig Schmidinger, Dachau

Page 63: © VG Bild-Kunst, Bonn 2010

Translation: Margaret Marks, Fürth
Typography: Margret Russer, Munich
Layout and Production: Edgar Endl
Reproduction: Lanarepro, Lana (South Tyrol)
Printing and Binding: F&W Mediencenter, Kienberg

Bibliographic information published by the Deutsche Nationalbibliothek
The Deutsche Nationalbibliothek lists this publication in the Deutsche Nationalbibliografie; detailed bibliographic data are available in the internet at http://dnb.d-nb.de

ISBN 978-3-422-02238-6
© 2010 Deutscher Kunstverlag GmbH Berlin München